W9-BQU-354

the little book of
Creativity

David E. Carter

HARPER DESIGN international

An imprint of HarperCollins*Publishers*

the little book of
Creativity

First published in 2004 by:
Harper Design International,
An imprint of HarperCollins*Publishers*
10 East 53rd Street
New York, NY 10022

Distributed throughout the world by:
HarperCollins International
10 East 53rd Street
New York, NY 10022
Fax: (212) 207-7654

HarperCollins books may be purchased for educational, business,
or sales promotional use. For information, please write: Special
Markets Department, HarperCollins Publishers Inc., 10 East 53rd
Street, New York, NY 10022.

Book design by Designs on You!
Suzanna and Anthony Stephens

Library of Congress Control Number: 2004109398

ISBN 0-06-074801-X

Printed in China by Everbest Printing Company through Four
Colour Imports, Louisville, Kentucky.
First Printing, 2004

Creativity.

Ask 100 creative people to define the word, and you may get 100 answers.

So when I was asked to produce a book on creativity, I wanted to create (there's the word) a book that would be highly useful to creative people. I wanted to create a book that would serve as a springboard to help readers *get* creative ideas for advertising and graphic design.

With that goal in mind, I then made a list of creative methods: photo manipulation, words that work, surprise, etc., and I set about finding some really great examples of creative use of these methods.

And here it is: *The Little Book of Creativity*. For those who create in the arenas of advertising and graphic design, we all know the process. Brainstorming, groupthink, or bouncing ideas off the wall—call it what you will. The purpose of this book is to help with what I call solitary brainstorming: looking at examples of great work and letting your creative mind use these as springboards for *your own* great ideas.

The Little Books series is designed for two levels of use: first is the seasoned professional who will see the work here and instantly gain inspiration from the visual and word images. The other level is the less experienced ad and design person. For those, my notes and thoughts accompany each piece chosen for the book.

So, flip through the book, and be inspired by the great work within.

Be creative.

table of
Contents

This is a house-
warming invitation.
There's the house.
And here's the...
match. A real
match.

Clever.

creative firm
TWIST inc.
designer
Kristine Anderson Dahms
photographer
Rick Dahms
client
Twist & Shout,
Vashon Island, WA

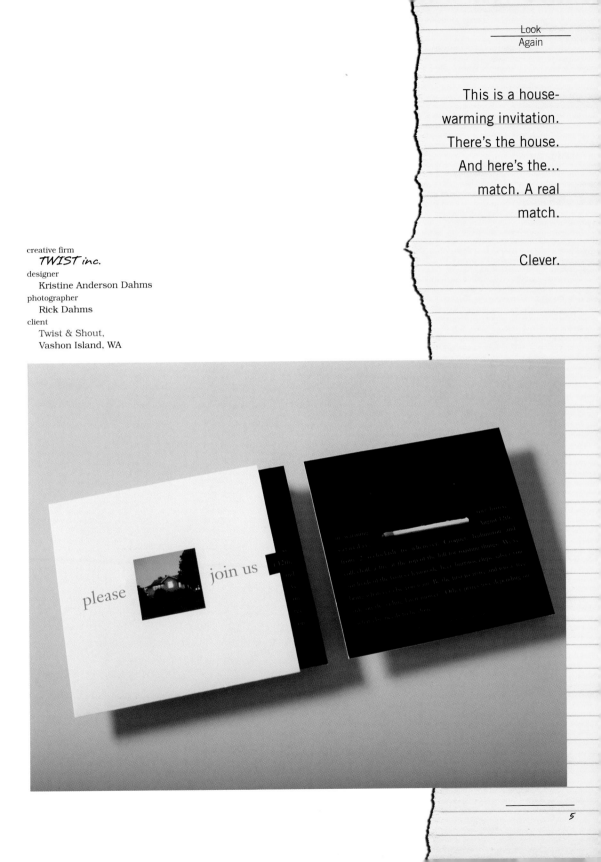

What's this? It's a dog shampoo.

And the shape: A fire hydrant.

The design connects with the product's target market, makes it simply unforgettable.

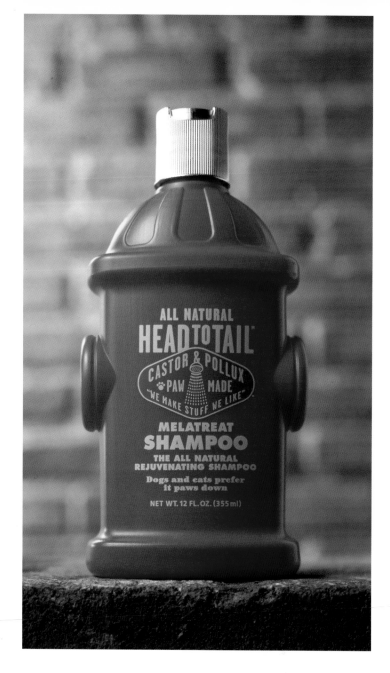

creative firm
 Sandstrom Design
art director
 Jon Olsen
designer
 Starlee Matz
production manager
 Kelly Bohls
client
 Castor & Pollux

creative firm
Lure Design
designer
Jeff Matz
client
Foundation

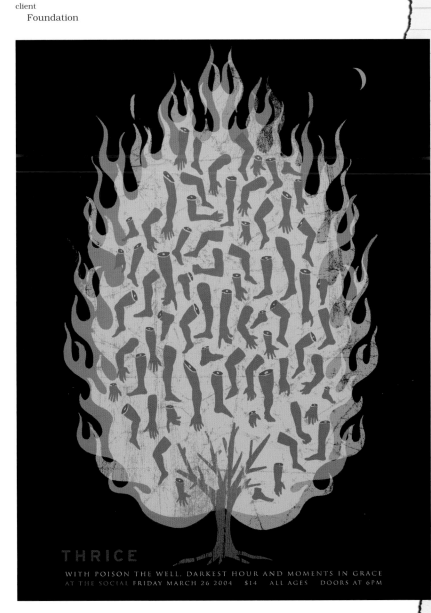

This poster shows a tree. Wait. The tree seems to have flames coming from the edges.

But they're subtle, since they're not hot colors. And inside the tree, there are arms, legs, feet and hands...

And now that we have your full attention, it might be nice to read the copy at the bottom.

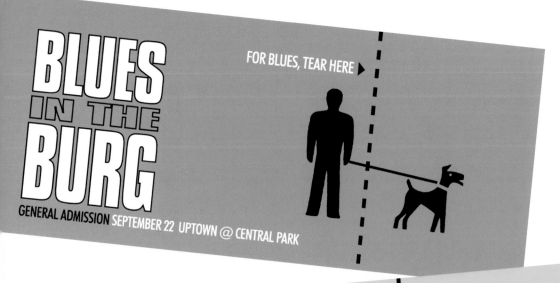

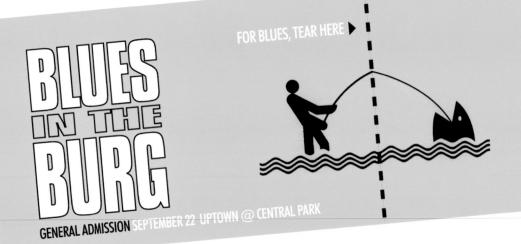

creative firm
 Arnika
designer
 Michael Ashley
copywriters
 Michael Ashley, Dinesh Kapoor
client
 Boys and Girls Club of America

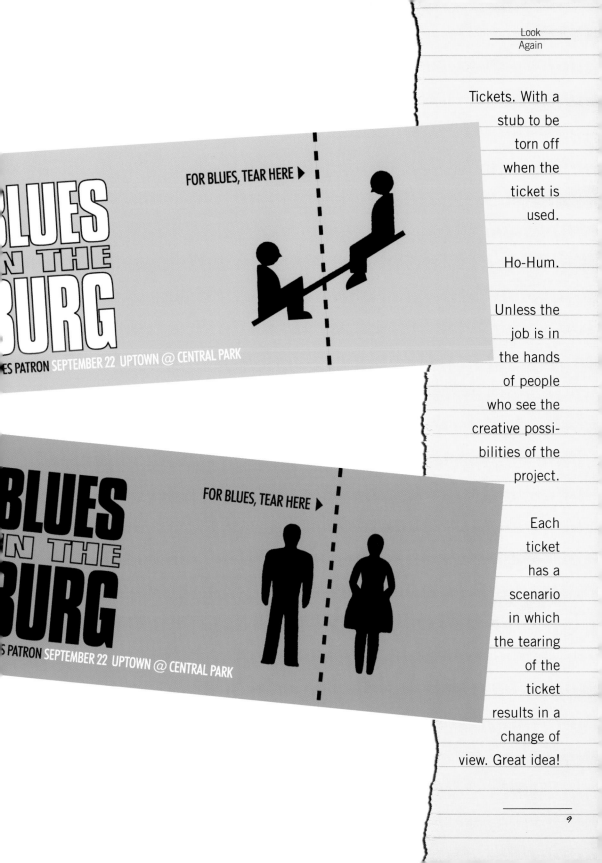

Tickets. With a stub to be torn off when the ticket is used.

Ho-Hum.

Unless the job is in the hands of people who see the creative possibilities of the project.

Each ticket has a scenario in which the tearing of the ticket results in a change of view. Great idea!

FOR BLUES, TEAR HERE ▶

BLUES IN THE BURG

ES PATRON SEPTEMBER 22 UPTOWN @ CENTRAL PARK

FOR BLUES, TEAR HERE ▶

BLUES IN THE BURG

S PATRON SEPTEMBER 22 UPTOWN @ CENTRAL PARK

It looks like a
cigarette pack,
and the word
"cigarette" is right
there. But the X is
the big attraction
on the X Pack
package.

Once you read the
copy, you see that
this is a product
to help you
become an Ex-
smoker. No BS.

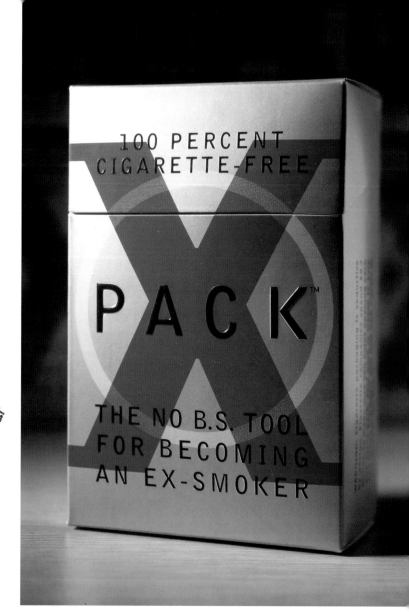

creative firm
Sandstrom Design
art director
Jon Olsen
designer
Shanin Andrew
production manager
Kirsten Cassidy
client
Public Services

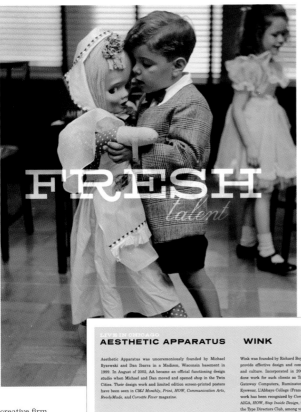

creative firm
Wink Inc.

The illustration is a grabber. The young boy dancing...with a...doll. The use of pastel colors further draws the eye inward. Only when you get to the copy on the back do you find the premise of the piece. Fresh. Talent. Creative.

This logo has an "industrial age" look but then you see the glass pane the man is holding. The transparency of that element gives this a "take a second look" appeal that grabs the eye.

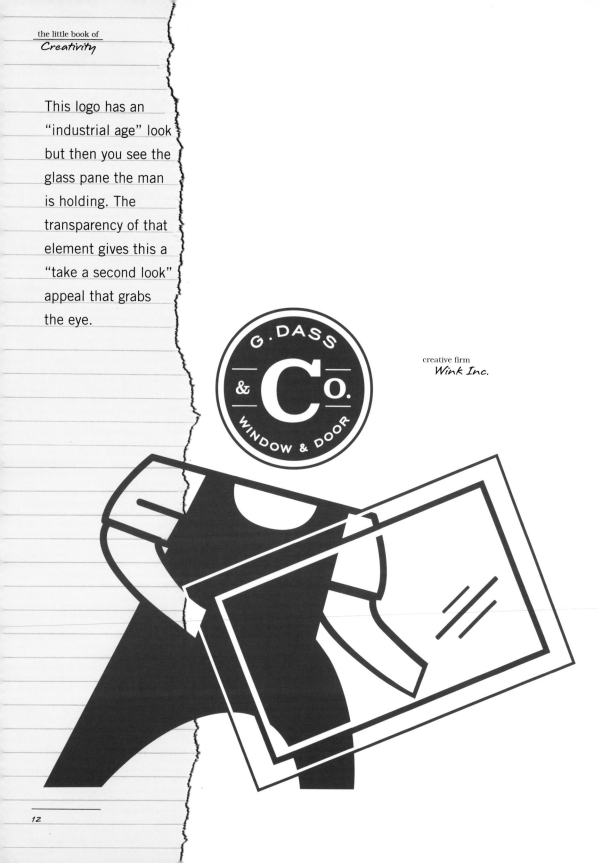

G. DASS
& C o.
WINDOW & DOOR

creative firm
Wink Inc.

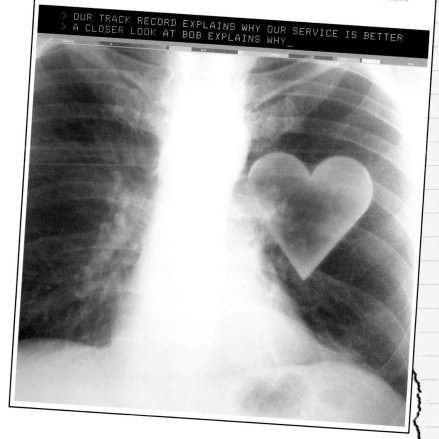

>> At LocateADoc.com, we're not your typical patient marketing referral service. Besides a reputation for building your patient base, we're also known for something even more uncommon: a big heart. We're one of those young, innovative companies who still believe in caring for the customer. With over a half-million potential patients visiting the LocateADoc.com network each month, you'll receive a list of qualified leads, along with their address, phone number and e-mail address. We'll even show you how to get the most out of each lead we provide. For more information call toll free 1-877-665-6798 ext. 102 today. Feel free to examine the personnel. You'll find that everyone looks kinda like Bob. LocateADoc.com
A PRODUCT OF MOJO INTERACTIVE

>> OUR TRACK RECORD EXPLAINS WHY OUR SERVICE IS BETTER
>> A CLOSER LOOK AT BOB EXPLAINS WHY ...

Look at the chest x-ray. Look again, you see a heart. The kind of heart that says "we care". Re-placing the expected image with the unexpected...is rewarding for the audience as well as the creatives who break down walls to create good work.

creative firm
Lure Design
art director, designer
Jeff Matz
copywriter
Jane Harrison
client
Mojo Interactive

It's "only" a skate-board design.

But it's also a nice piece of abstract art.

When you read the title of the design: "Across the Con-crete Prairies," you see images of horses, and sud-denly, the skate-board is tranformed into a horse, and the skateboarder into a horseman.

And the owner has a product with a truly distinctive design.

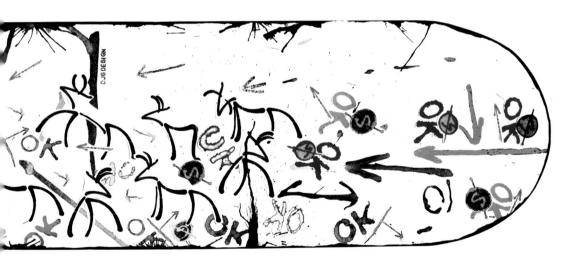

creative firm
DJG Design
designer
Danny J. Gibson
client
Lively & Arts Incubator

Not your usual portrait. This graphic takes us inside the dermis and epidermis and into the place where only medical students usually venture. The two-color job is a real attention-grabbing piece and the layout has several nice touches. Notice the mirror image type near the top of the piece.

creative firm
 Lure Design
designer
 Jeff Matz
client
 Figurehead Productions

winston-salem symphony 2000/2001 season

creative firm
Henderson Bromstead
art director
Hayes Henderson
designer, illustrator
Billy Hackley

The colors grab you first. Then, you look at the lines that make up the colors. That's when you see that they are all musical images. Not coincidentally, the shape of the graphic suggests that the conductor is at the front and the orchestra is following his lead, making beautiful music (and graphics).

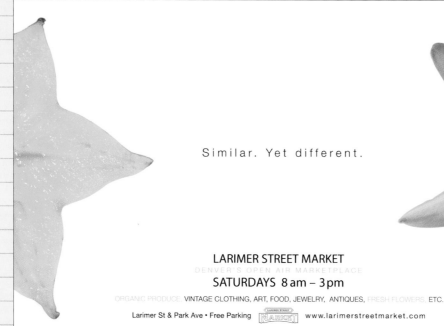

Similar. Yet different.

LARIMER STREET MARKET
DENVER'S OPEN AIR MARKETPLACE
SATURDAYS 8 am – 3 pm

ORGANIC PRODUCE, VINTAGE CLOTHING, ART, FOOD, JEWELRY, ANTIQUES, FRESH FLOWERS, ETC.

Larimer St & Park Ave • Free Parking [MARKET] www.larimerstreetmarket.com

Each of these posters has two distinctively different items, but with similar visual profile, as a way to show the variety of items available at the market. Clever idea, and the use of white space is excellent.

creative firm
Cultivator Advertising & Design
creative directors
 Tim Abare, Chris Beatty
designer
 August Sandberg
copywriter
 Tim Abare
client
 Larimer St. Market

Objects of proportional desire.

LARIMER STREET MARKET
DENVER'S OPEN AIR MARKETPLACE
SATURDAYS 8 am – 3 pm

ORGANIC PRODUCE, VINTAGE CLOTHING, ART, FOOD, JEWELRY, ANTIQUES, FRESH FLOWERS, ETC.

Larimer St & Park Ave • Free Parking [MARKET] www.larimerstreetmarket.com

You see it too, don't you?

LARIMER STREET MARKET
DENVER'S OPEN AIR MARKETPLACE
SATURDAYS 8 am – 3 pm

ORGANIC PRODUCE, VINTAGE CLOTHING, ART, FOOD, JEWELRY, ANTIQUES, FRESH FLOWERS, ETC.

Larimer St & Park Ave • Free Parking [MARKET] www.larimerstreetmarket.com

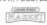

The poster for Hamlet is a powerful image with the red ink giving a signal of the tragedy to come. Then you see the bar code, a phrase that was definately not in Shakespeare's writing vocabulary. (To scan...or not to scan...that is the question.)

Juxtaposing images which are normally not related can bring a fresh approach to the creativity process.

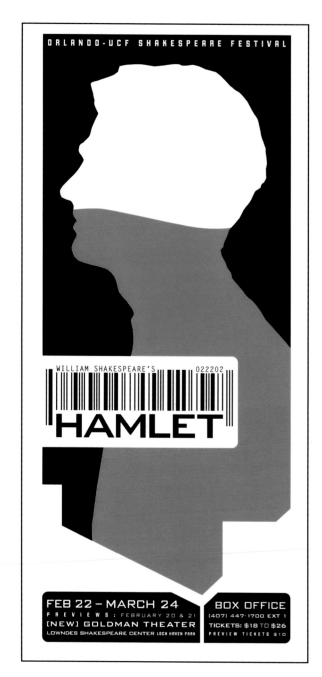

creative firm
Lure Design
designer, illustrator
Paul Mastriani
client
Orlando UCF Shakespeare Festival

creative firm
 Doyle Partners
designer
 Stephen Doyle
client
 IBM

leadership.
magazine
vol.3 no.2

Creativity is often about changing expectations. The oversized dice on the cover grab your attention, but when you look to see what the dice turned up, you see the name of the magazine. Unforgettable.

At first, you see the people, in various colors. Are they all "clones" of one another? Then you see the type...you read, and communication has taken place.

In a very creative way.

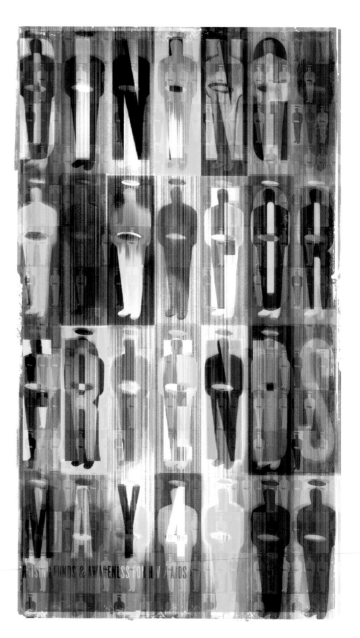

creative firm
Henderson Bromstead
art director, designer
Hayes Henderson
illustrator, designer
Billy Hackley

creative firm
 Michael Schwab Studio
art directors
 Erica Hess, Kevin Brown
client
 Peet's Coffee & Tea

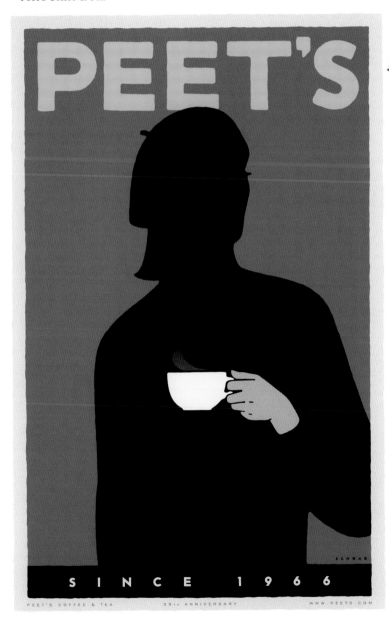

The Peet's logo features a silhouette of a man? Or is it a woman? The hand is in color; everything else is in black. The beret is unisex. So is the haircut. Is the eyelash a clue? Do we know? Do we *want* to know? Yes.

Looks like a paper

swatch book.

Look again.

It's a portfolio of

work for a graphic

design firm.

Eye-catching,

compact and

effective.

creative firm
Viva Dolan
creative director, designer, illustrator
Frank Viva
copywriter
Doug Dolan
photographer
Ron Baxter Smith

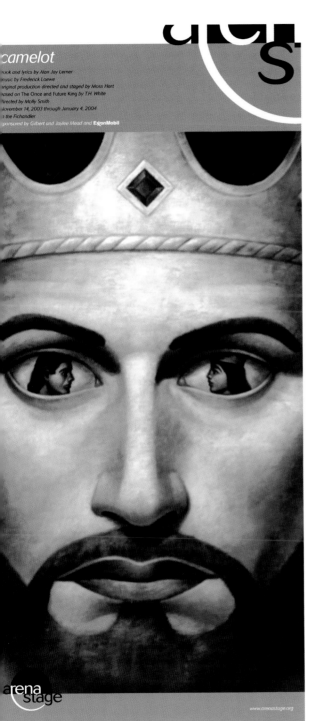

camelot

book and lyrics by Alan Jay Lerner
music by Frederick Loewe
original production directed and staged by Moss Hart
based on The Once and Future King by T.H. White
Directed by Molly Smith
November 14, 2003 through January 4, 2004
in the Fichandler
sponsored by Gilbert and Jaylee Mead and ExxonMobil

arena
stage

www.arenastage.org

This illustration of the Once and Future King goes beyond the ordinary when you look into the king's eyes.

creative firm
Mires
creative director
Scott Mires
designer
Jen Cadam
illustrators
Jody Hewgill,
Mike Benny
copywriters
Eric Labrecque,
Anne Marie Czeban,
Maggie Boland
client
Arena Stage

The poster for a performance of Cyrano de Bergerac features a huge feather. Then you see the profile of Cyrano and his famous nose. Excellent execution and a two-color job makes the printing cost very afford-able.

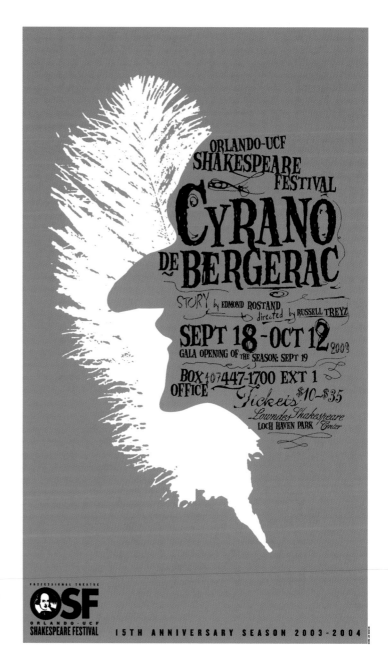

creative firm
Lure Design
designer, illustrator
Paul Mastriani
client
Orlando UCF Shakespeare Festival

The use of type on top of the illustration gives this poster powerful holding power. The use of colors here is exceptional, as the red lipstick becomes a dominant visual element.

creative firm
Mires
creative director
Scott Mires
designer
Jen Cadam
illustrators
Jody Hewgill,
Mike Benny
copywriters
Eric Labrecque,
Anne Marie Czeban,
Maggie Boland
client
Arena Stage

In the Gutter is a graphic design showcase that uses the gutter of a publication to create interesting visual images. As a promotional piece, this is outstanding. But as a creative exercise, it's the mental equivalent of a vigorous workout at the health club.

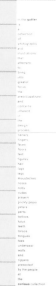

creative firm
Viva Dolan
creative director, designer, illustrator, copywriter
Frank Viva
photographer
Ron Baxter Smith

Many of the best creatives I know often have "mental workouts", just for fun. Some involve visuals, others words.

At first glance, this is a newspaper, albeit very well designed with very nice photography. Then you see that it's actually a promotional piece for a photographer. The photos, of course, are outstanding. But the design and copy also capture and hold the attention. Thinking out of the box often means going with an unusual solution to a common problem.

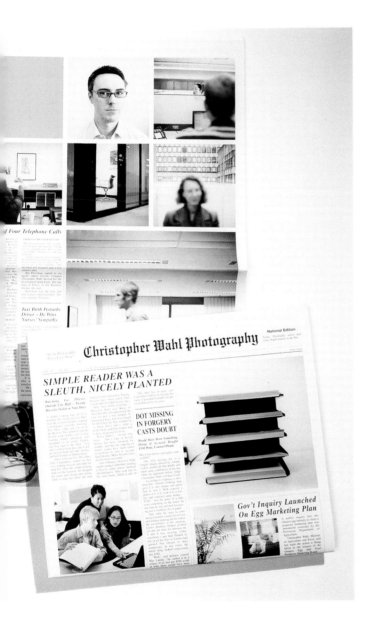

creative firm
Viva Dolan
creative director
Frank Viva
designer
Sarah Wu
photographer, copywriter
Christopher Wahl
copywriter
Archival

This "dictionary page" has two entries highlighted: The green highlight shows McGaughy Design, and a holiday message. The red features the word "procrastinate" as in putting off doing self-promotional holiday greetings until it's too late. Clever way to display the creativity of a design firm.

713 **procession** □ **proenforcement**

carrying out or going through a particular series of actions. **4.** the course or lapse, as of time. **5.** *Biol.* a natural outgrowth or projecting part. **6.** *Law.* a court action or summons. —*v.t.* **7.** to treat or prepare by some particular process, as in manufacturing. **8.** to handle in a routine, orderly manner.

pro·ces·sion (prǝ sesh′ǝn), *n.* **1.** a line or group of persons or things moving along in an orderly way, as in a parade. **2.** any continuous movement forward.

pro·ces·sion·al (prǝ sesh′ǝ nǝl), *n.* a hymn suitable for accompanying a religious procession. —**pro·ces′sion·al·ly,** *adv.*

proc·es·sor (pros′es ǝr), *n.* **1.** Also, **proc′ess·er.** a person or thing that processes. **2.** the device within a computer that handles data. **3.** See **food processor.**

pro·claim (prō klām′, prǝ-), *v.t.* to announce formally or publicly. — **pro·claim′er,** *n.* —**proc·la·ma·tion** (prok′lǝ mā′shǝn), *n.*

pro·cliv·i·ty (prō kliv′i tē), *n., pl.* **-ties.** a strong habitual inclination or tendency, esp. toward something bad.

pro·con·sul (prō kon′sǝl), *n.* **1.** a governor or military commander of a province in ancient Rome. **2.** any administrator over a dependency or an occupied area. —**pro·con′su·lar,** *adj.* —**pro·con′su·late,** *n.* —**pro·con′sul·ship′,** *n.*

pro·cras·ti·nate (prō kras′tǝ nāt′, prǝ-), *v.i., v.t.,* **-nat·ed, -nat·ing.** to put off (action) habitually till another day or time. (commonly seen with graphic designers who "habitually put off" doing their self-promotional holiday greetings until it's too late.)

pro·cre·ate (prō′krē āt′), *v.t., v.i.,* **-at·ed, -at·ing.** to beget or bring forth (offspring). —**pro′cre·a′tion,** *n.*

Pro·crus·te·an (prō krus′tē ǝn), *adj.* (*often l.c.*) tending to produce conformity by violent or arbitrary means.

proc·tol·o·gy (prok tol′ǝ jē), *n.* the branch of medicine dealing with the rectum and anus. —**proc′to·log′ic** (-t°loj′ik), **proc′to·log′i·cal,** *adj.* —**proc·tol′o·gist,** *n.*

proc·tor (prok′tǝr), *n.* a university official who supervises students during examinations. —**proc·to′ri·al** (-tōr′ē ǝl, -tôr′-), *adj.*

proc·to·scope (prok′tǝ skōp′), *n.* an instrument for visual examination of the interior of the rectum. —**proc·to-**

scop·ic (prok′tǝ skop′ik), *adj.* — **proc·tos·co·py** (prok tos′kǝ pē), *n.*

proc·u·ra·tor (prok′yǝ rā′tǝr), *n.* (in ancient Rome) an imperial official with fiscal or administrative powers.

pro·cure (prō kyoor′), *v.t.,* **-cured, -cur·ing. 1.** to obtain by effort. **2.** to cause to occur. **3.** to obtain (women) for the purpose of prostitution. —**pro·cur′a·ble,** *adj.* —**pro·cure′ment,** *n.* —**pro·cur′er,** *n.* — **pro·cur′ess,** *n.fem.*

prod (prod), *v.,* **prod·ded, prod·ding,** *n.* —*v.t.* **1.** to poke or jab with something pointed. **2.** to rouse to do something. —*n.* **3.** a poke or jab. **4.** any pointed instrument for prodding, as a goad.

prod., 1. produce. **2.** produced. **3.** producer. **4.** product. **5.** production.

prod·i·gal (prod′ǝ gǝl), *adj.* **1.** wastefully extravagant. **2.** lavishly abundant. —*n.* **3.** a person who is wastefully extravagant. —**prod′i·gal′i·ty** (-gal′i tē), *n.* —**prod′i·gal·ly,** *adv.* —**Syn. 1.** profligate. **2.** bountiful, profuse.

pro·di·gious (prǝ dij′ǝs), *adj.* **1.** extraordinary in size or amount. **2.** wonderful or marvelous: *a prodigious feat.* —**pro·di′gious·ly,** *adv.* — **pro·di′gious·ness,** *n.*

pro·duce (*v.* prǝ dōōs′, -dyōōs′; *n.* prod′ōōs, -yōōs, prō′dōōs, -dyōōs), *v.,* **-duced, -duc·ing,** *n.* —*v.t.* **1.** to bring into existence by labor, machine, or thought. **2.** to bring forth or yield. **3.** to present or show for inspection. **4.** to cause or give rise to. **5.** to get (a play, motion picture, etc.) organized for public presentation. —*v.i.* **6.** to bring forth or yield something. —*n.* **7.** something produced, esp. vegetables and fruits. —**pro·duc′er,** *n.* —**pro·duc′i·ble,** *adj.*

prod·uct (prod′ǝkt, -ukt), *n.* **1.** a thing produced, as by labor. **2.** a result or outcome. **3.** *Math.* the result obtained by multiplying two or more quantities together.

pro·duc·tion (prǝ duk′shǝn), *n.* **1.** the act of producing. **2.** product (def. 1). **3.** an amount that is produced. **4.** the organization and presentation of a dramatic entertainment. —**pro·duc′tive,** *adj.* —**pro·duc′tive·ly,** *adv.* — **pro·duc·tiv·i·ty**

Mc·Gaug·hy De·sign (mǝ gaˈ hē · di zīn′) *wishes* **1.** you **2.** your family, a joyous and safe holiday season—*and a happy new year!*

pro·em (prō′ǝm), *n.* an introductory discourse.

pro·cler′i·cal, *adj.*
pro·com′mu·nism, *n.*
pro·com′mu·nist, *adj., n.*

pro·com′pro·mise′, *adj.*
pro·con·ser·va′tion, *adj.*

pro·dem·o·crat′ic, *adj.*
pro′dis·ar′ma·ment, *adj.*
pro′en·force′ment, *adj.*

creative firm

McGaughy Design

art director designer

Malcolm McGaughy

Calendars are everywhere. Most are so boring that the 365 days can seem like dog years. This one uses interesting faces, all with messages written on each face. Clever, creative, and eye-catching.

creative firm
Viva Dolan
creative director, facial lettering
Frank Viva
designer, facial lettering
Sarah Wu
photographers
Jeffrey Graetsch, David Stromberg
copywriter
World Literacy of Canada

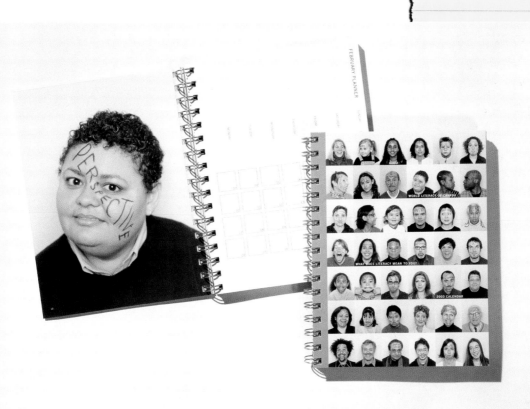

This piece turns the ubiquitous groundbreaking shovel into...a glass of champagne. What a stroke of genius, especially when you consider that the typical groundbreaking invitation is type only—and all too often, it's Old English type.

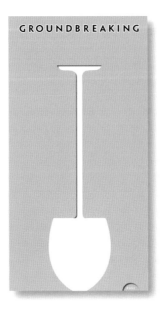

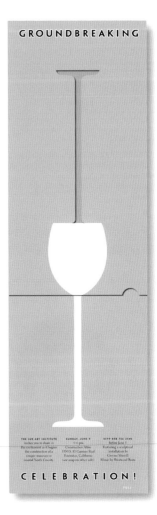

creative firm
Mires
creative director, copywriter
John Ball
designer, illustrator
Tavo Galindo
client
Lux Art Institute

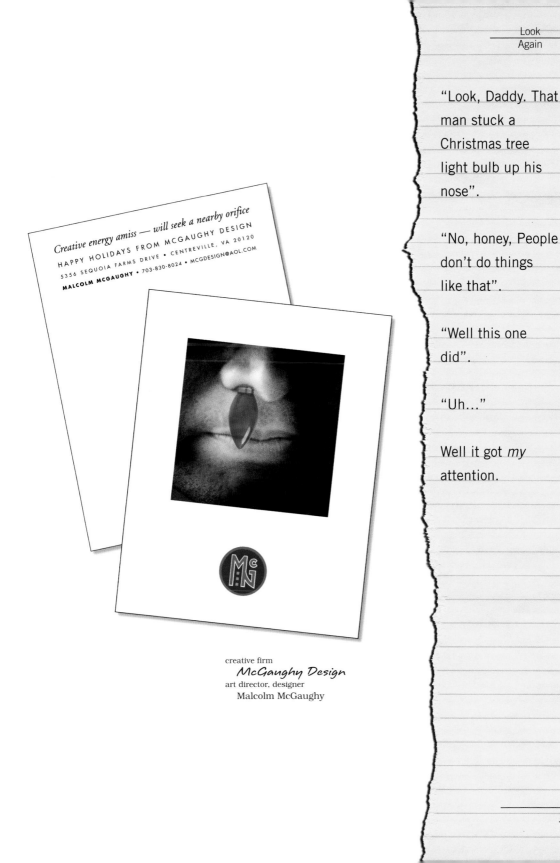

Creative energy amiss — will seek a nearby orifice

HAPPY HOLIDAYS FROM MCGAUGHY DESIGN

5356 SEQUOIA FARMS DRIVE • CENTREVILLE, VA 20120

MALCOLM MCGAUGHY • 703-830-8024 • MCGDESIGN@AOL.COM

creative firm
McGaughy Design
art director, designer
Malcolm McGaughy

"Look, Daddy. That man stuck a Christmas tree light bulb up his nose".

"No, honey, People don't do things like that".

"Well this one did".

"Uh…"

Well it got *my* attention.

Adult Filmmakers,
and Southern
Clergymen.

Both happy.

Great concept.

creative firm
BBDO Atlanta
creative directors
Dave Stanton,
Jackie Hathiramani
art director
Steve Andrews
copywriter
Mike Weidner

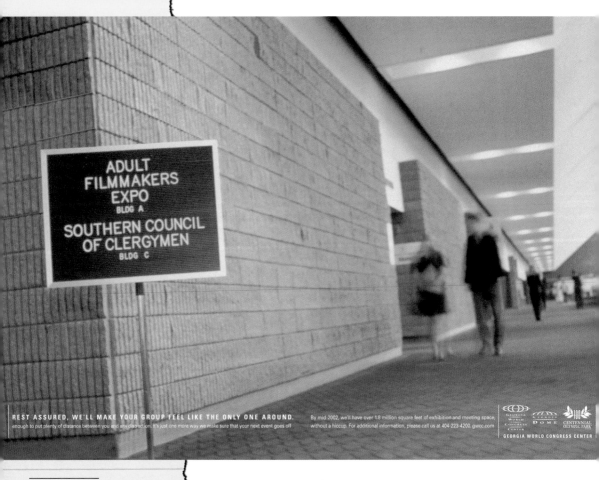

ADULT
FILMMAKERS
EXPO
BLDG A

SOUTHERN COUNCIL
OF CLERGYMEN
BLDG C

REST ASSURED, WE'LL MAKE YOUR GROUP FEEL LIKE THE ONLY ONE AROUND. enough to put plenty of distance between you and any distraction. It's just one more way we make sure that your next event goes off By mid-2002, we'll have over 1.8 million square feet of exhibition and meeting space, without a hiccup. For additional information, please call us at 404-223-4200. gwcc.com

GEORGIA WORLD CONGRESS CENTER

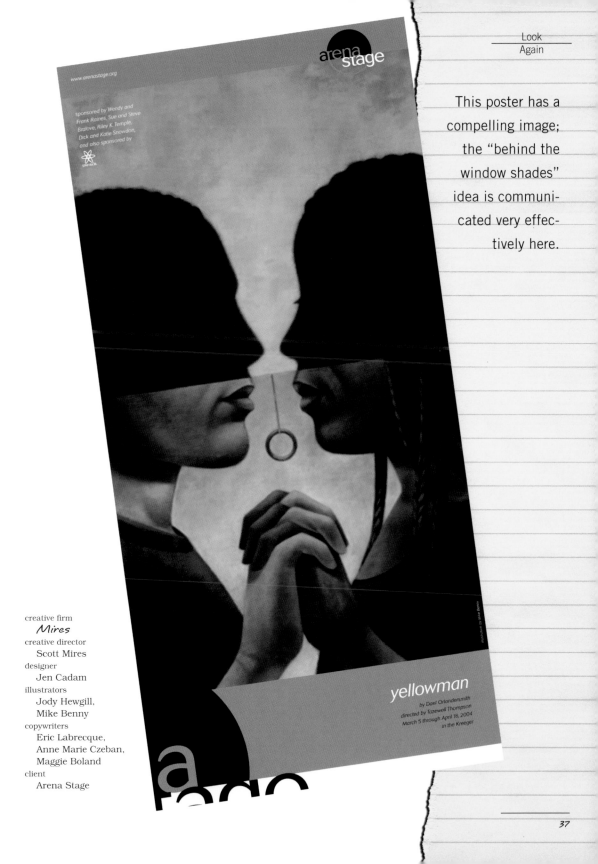

This poster has a compelling image; the "behind the window shades" idea is communicated very effectively here.

creative firm
 Mires
creative director
 Scott Mires
designer
 Jen Cadam
illustrators
 Jody Hewgill,
 Mike Benny
copywriters
 Eric Labrecque,
 Anne Marie Czeban,
 Maggie Boland
client
 Arena Stage

yellowman
by Dael Orlandersmith
directed by Tazewell Thompson
March 5 through April 18, 2004
in the Kreeger

ANOTHER
FINE FILA BRAZILLIA
MESS:

A Nº1 BUSHY / DON'T MIND IT I DO
Nº2 MENSE HERNTS / ALLES IST DADA (ELECTRONICAT MIX)
Nº3 JULEX MUSIC / BALON UND STEISSWWARZ, SCREWED UP VOCAL MIX)
B Nº1 YELLO / I LOVE YOU
Nº2 XAVIER CUGAT & HIS ORCHESTRA / BRAZIL
C Nº1 NAAB / BACK BY DOPE DEMAND
D Nº1 HEITOR / LIGEIRIN (AFRON MIX)
Nº2 KILLING JOKE / BLOODSPORT
Nº3 GRAND POPO FU / MEN ARE NOT NICE GUYS
E Nº1 GOLFHAFT STREET MACHINE (EWFLAN TRAXMODE STEP MIX)
Nº2 FUPER DELUXE / GIRL
Nº3 KINGS OF THE WILD FRONTIER / THEME FROM 17

ACID HOME : LIKE ACID HOUSE, ONLY COMFIER

creative firm
Red Design

ANOTHER
FINE FC KAHUNA
MESS:

Look. Balloons.

Look again.

Balloons stomped
into little pieces on
the floor.

You *must* read the
copy.

For Swiss Night, this poster uses simulated Swiss cheese. And the holes include stars and a moon. Brilliant execution of a highly creative idea.

creative firm
Blattner Brunner
designer
Dave Vissat
client
Swiss American Society of Pittsburgh

This wire-frame drawing keeps bringing the eye back, time and again. Will the viewer discover something new on this return trip? Simple colors repeated in different shapes give this an appeal that is difficult to resist.

SECREST ARTISTS SERIES

creative firm
Henderson Bromstead
designer, illustrator
Hayes Henderson

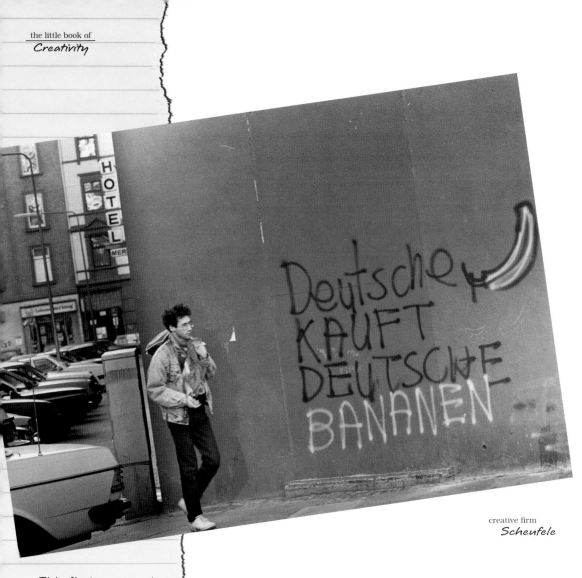

creative firm
Scheufele

This first appears to fit under "Urban studies, black & white photography," but then you see that it's actually an advertisement. For bananas.

OK, think about this.
Bird houses made
from old books, and
a headline for the
very literate.

creative firm
Blattner Brunner
creative director
Dave Vissat
copywriter
Ray Peckich
photographer
Duane Rieder
client
Wild Wings

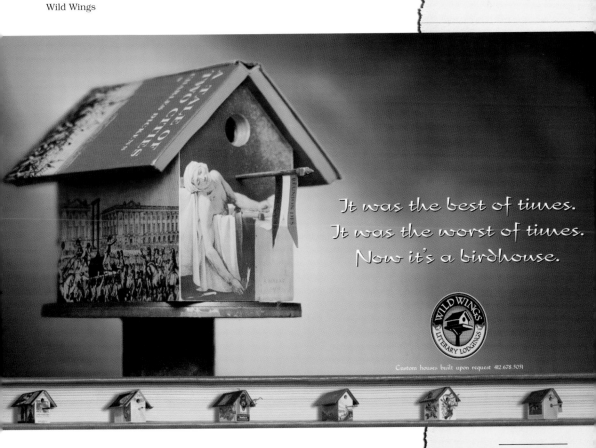

*It was the best of times.
It was the worst of times.
Now it's a birdhouse.*

WILD WINGS
LITERARY LODGINGS

Custom houses built upon request 412.678.5051

creative firm
Scheufele

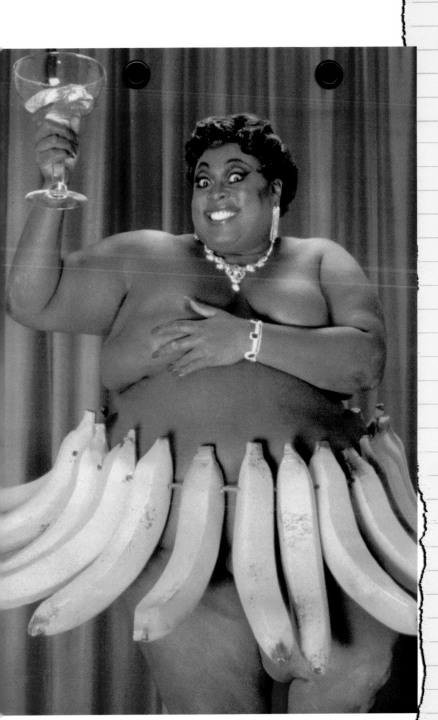

The photo at left
looks like it might
be from an old
movie titled
something like
"Going on Down
to Rio to
do a Banana
Advertisement."

On the right is a
more modern
version of the
same concept.

Die Querdenker suchen und finden.
Im Stellenmarkt von LZ und LZ | NET.

Gute Köpfe, erste Wahl.

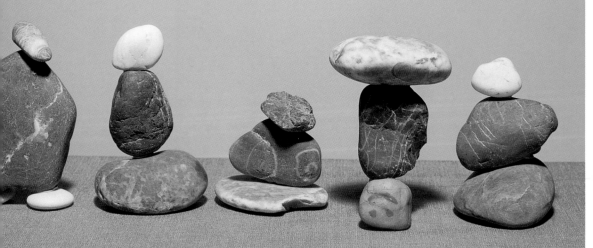

Kontakt: Bianca Burmester
Anzeigenverkaufsleitung
Stellenmarkt LZ und LZ | NET
Telefon: 069-75 95-17 52
E-Mail: burmester@lz-net.de

www.lz-net.de/jobs

**Lebensmittel
Zeitung** + LZ | NET

Die Leuchten suchen und finden.
Im Stellenmarkt von LZ und LZ | NET.

Gute Köpfe, erste Wahl.

Kontakt: Bianca Burmester
Anzeigenverkaufsleitung
Stellenmarkt LZ und LZ | NET
Telefon: 069-7595-1752
E-Mail: burmester@lz-net.de

www.lz-net.de/jobs

Lebensmittel
Zeitung + LZ | NET

The lamps piece
is a good example
of creating focus
among similar
objects by making
one stand out
with a simple
position change.
The rocks ad does
the same thing,
with a whimsical
touch.

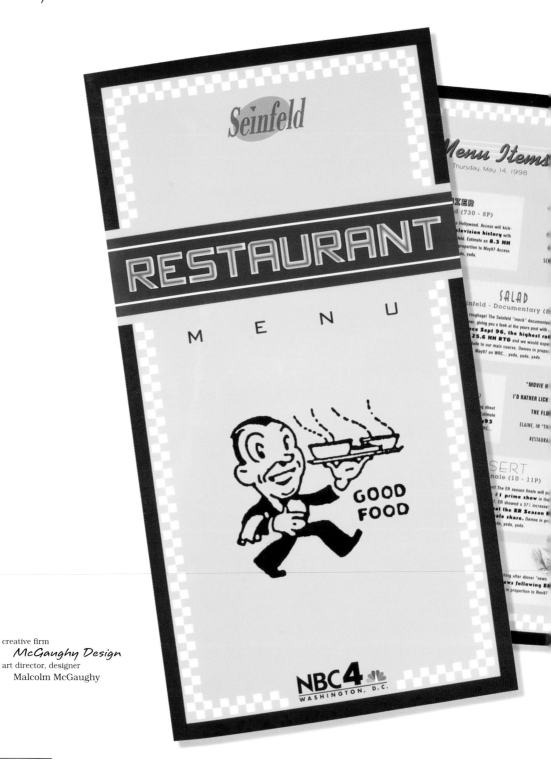

creative firm
McGaughy Design
art director, designer
Malcolm McGaughy

SPECIALS

The Cosmo

Time	Program	A25 - 54
730 -8P	Access Hollywood	
8 -9P	Seinfeld Retrospective	5.0
11 - 1135P	News4 at 11	23.1
1135P - 1235A	Tonight Show	17.9
		4.8

Totals
Commercials: 4x :30
A25 - 54 GRPs: 50.8

Cost ■■■■
(Not that there is anything wrong with that!)

The Uncle Leo

Time	Program	A25 - 54
730 -8P	Access Hollywood	
10 - 11P	ER Season Finale	5.0
11 - 1135P	News4 at 11	31.8
1135P - 1235A	Tonight Show	17.9
		4.8

Totals
Commercials: 4x :30
A25 - 54 GRPs: 59.5

Cost ■■■■
(Not that there is anything wrong with that!)

"NOBODY TAKES
BETTER CARE OF THEIR
HAIR THAN ME. YOU
CAN SERVE DINNER
ON MY HEAD."
— ELAINE, IN
"THE DINNER PARTY"

Coffee
Tonight Show (1135P - 1235A)

Before you head off to bed, finish the night with a cup of The Tonight Show. As the
celebration continues, expect many surprises on The Tonight Show with a rating to
match. **In Jan96, the show delivered an 11.2 HH RTG.** Estimate
the same rating for The Tonight Show special presentation on WRC. Demos in proportion
to May97 Tonight Show on WRC... yada, yada, yada.

This menu for the NBC affiliate in Washington, D.C. is a tribute to Seinfeld. The Cosmo and the Uncle Leo are just two of the items you can get to eat here. Wait. This isn't a menu, it's a rate card for the station. Very good use of the Seinfeld franchise, and a clever way to package what could have been a dull sheet with ratings and prices.

The colors, along with the starkly simple design style used, make this a piece that reaches from the page and pulls your eyes inward. Change the colors to something more "conventional," and it loses its drawing power. Change the drawings to, say, photography, and it's not the same piece. Great concept and execution show how all the creative elements work together when a piece is "just right."

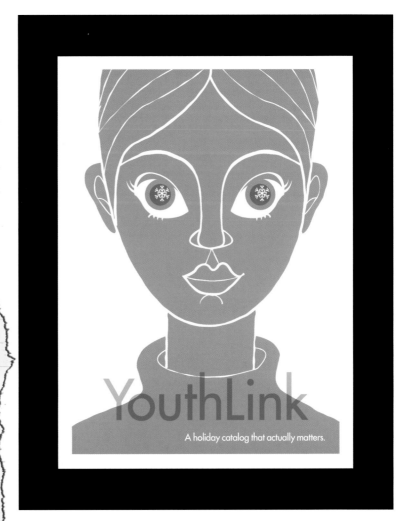

creative firm
Wink Inc.

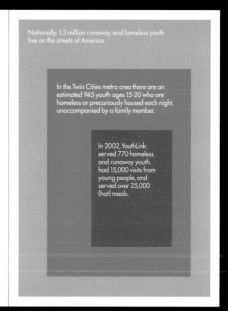

Nationally, 1.3 million runaway and homeless youth live on the streets of America.

In the Twin Cities metro area there are an estimated 945 youth ages 15-20 who are homeless or precariously housed each night, unaccompanied by a family member.

In 2002, YouthLink: served 770 homeless and runaway youth, had 15,000 visits from young people, and served over 25,000 (hot) meals.

Background

YouthLink in context.

Marshand

Case Study No. 1

In the fall of 2002, Marshand, a 15-year-old African-American youth, began his freshman year of high school at Patrick Henry High in North Minneapolis. Like many young people, he quickly developed difficulties in coping with the pressures of high school. He began committing more time to his social life than to his academic responsibilities, and eventually turned to skipping school. His lack of attendance resulted in suffering grades, and subsequently, failing marks in several of his classes. Shortly thereafter, he was referred to YouthLink's NewPath Partners program by the Hennepin County Attorney's office.

In the month before being assigned to his YouthLink case manager, Marshand attended school only 70% of the time. Working intensely with his case manager, Marshand began to show improvements. After two months with NewPath Partners, his attendance jumped to 83%. And at the time of discharge from case management, Marshand was attending classes daily and even voluntarily enrolled in evening classes to make up the few credits he'd lost due to his absences.

When asked why he chose to attend classes again and dedicate himself to his work, Marshand told his case manager that he had realized that skipping classes wasn't worth the cost of having to work his way through the system.

In 2002, NewPath Partners, YouthLink's truancy diversion program, served 332 young people. Truancy is the number one predictor among boys, and the number two predictor among girls, of future criminal activity.

The assign-
ment: create
ads for an
upholstery
shop. This
could easily
result in a dull
solution.

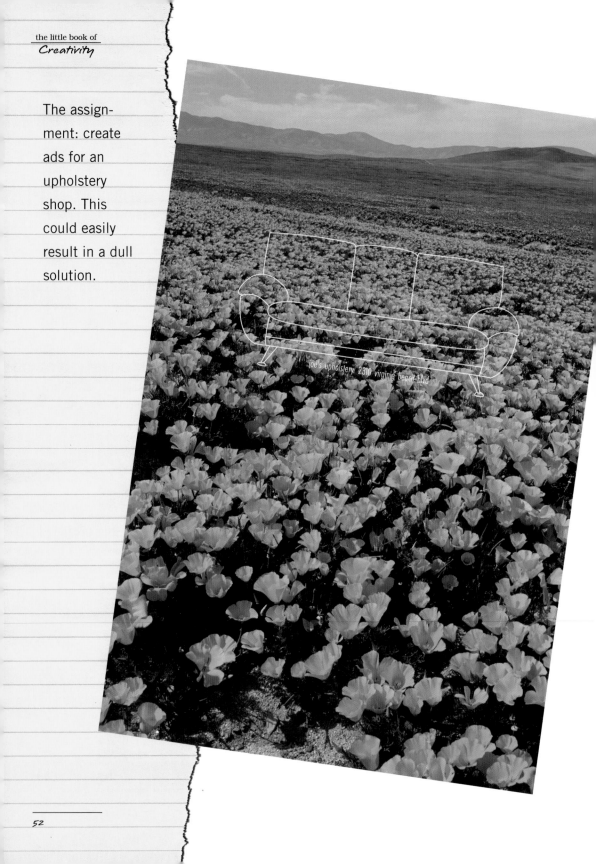

joe's upholstery 2310 virginia beach blvd

However, the use of color, in the form of large fields, with the outline of a sofa on top, is a powerful image.

creative firm
Arnika
designers
Michael Ashley, Diana Tung
copywriter
Michael Ashley
client
Joe's Upholstery

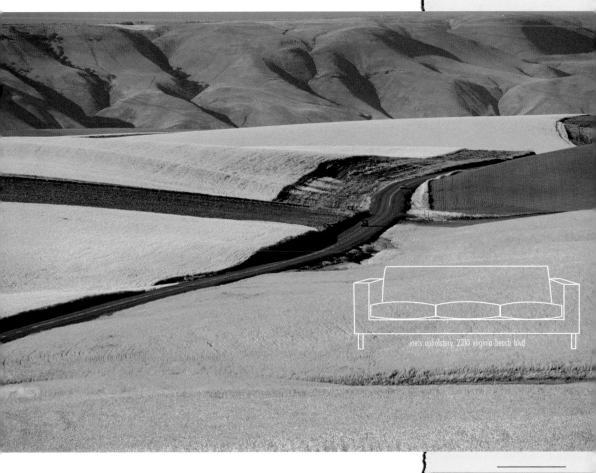

joe's upholstery. 2310 virginia beach blvd

The product, a personal UV monitor, almost begs to "show the bright sun" but this highly creative solution doesn't go for the obvious answer. The box has a deeply tanned color, and the photos show people in outdoor activity, with exposure to the sunlight

Unusual solution to an unusual assignment.

That's creativity!

creative firm
Wink Inc.

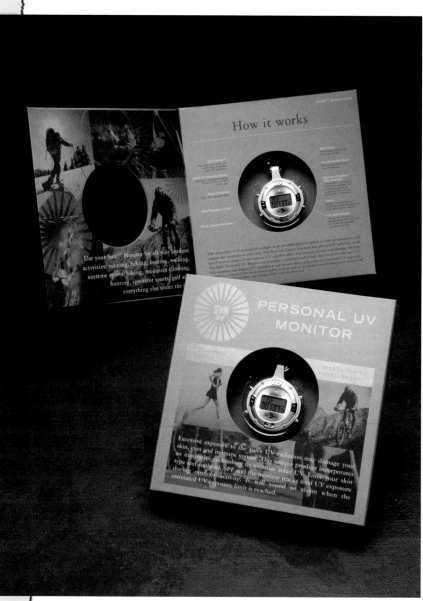

ROBERT MONDAVI

creative firm
 Michael Schwab Studio
art director
 Mark Dolin
client
 Robert Mondavi

This logo can be embossed, reduced and printed in any single PMS color and still retain its quality and simplicity.

This simple, yet effective, logo is included in the color section, even though it's black and white. Why? Because all logos should work equally well in black and white as in color; many do not.

The variety and placement of colors here stands out above all.

Based on ink coverage, the dominant color here is white, but based on impact, all of the colors here have their own presence.

And then there's the type. Or, actually, hand lettering. It dominates the page in a very positive way.

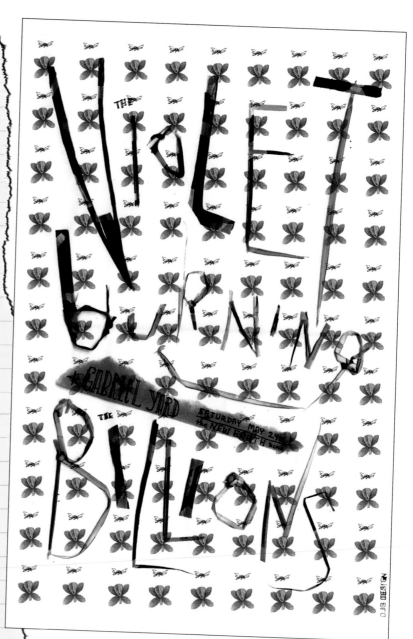

creative firm
DJG Design
designer, copywriter
Danny J. Gibson
client
Kevin Eschelman & The New Earth

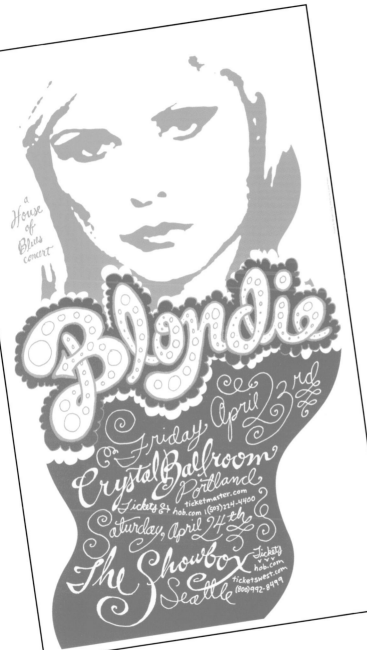

a House of Blues concert

Blondie

Friday April 23rd
Crystal Balfroom Portland
Tickets @ ticketmaster.com
hob.com 1(503)224-4400
Saturday, April 24th
The Showbox Seattle
Tickets
hob.com
ticketswest.com
(800)992-8499

creative firm
Modern Dog
art director, designer, illustrator
Michael Strassberger
client
House of Blues

This is an eye-catching poster for the musical artist Blondie.

The most interesting thing here is that you can almost see her blonde hair, yet the poster is a two-color printing job.

The choice of colors and the contrast of the two colors makes this happen. Add to that the photo technique and cropping of the head image. It works well.

White men's briefs—white package, with transparent wrapping. Right? Wrong. The duotone colors on the package act like a magnet, pulling the eye toward the product. And away from those competitors who use a common design solution.

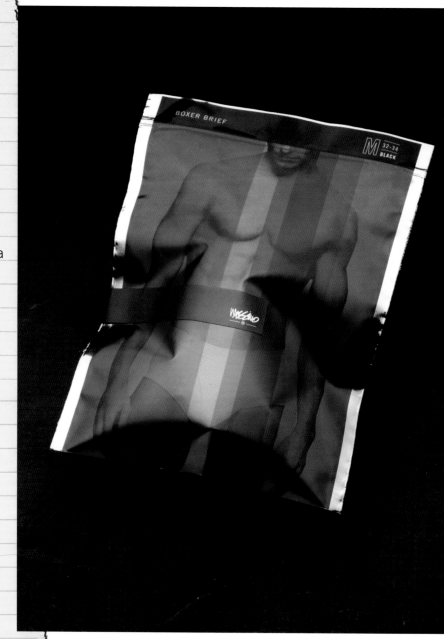

creative firm
Wink Inc.

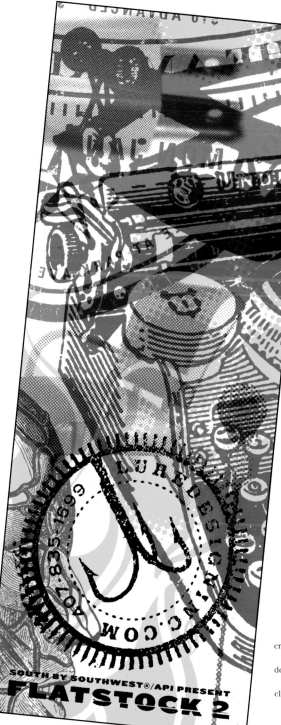

How many color layers can you see here? How many images are in this piece? The eye is invited to "come in and browse...you might find something you like." We did.

creative firm
Lure Design
designer
Jeff Matz
client
Lure Design

Nice menu. Nice colorful menu. Very wide menu. Looks like a good place to get a cuppa coffee or orange juce or a morning bagel. Except…it's a promotional piece for a six-color, wide format, digital printing company. Attention getting and memorable, and I'm sure they'll get you some coffee and a bagel while you're having your job printed there.

serving up six color for u

Rise and shine to a new day in wide-format digital printing. Introducing Impact Six-C, the first six color digital printing technology of its kind. This revolutionary color printing system guarantees that your projects will be stunningly, earth-shatteringly, well, the best darn projects ever. Because at Impact Imaging, we know beans about great digital printing.

Incredible six color without the processing jitters. No special software filters or file preparation on your end. It's all taken care of.

An incredibly smooth blend of colors. By adding light cyan and light magenta to the CMYK mix, Six-C printing delivers incredible detail, while the absolute purity of the inks produces the brightest oranges, greens, and yellows available. But don't worry, you won't need to buy any fancy appliances to set up six color. There is no new software or file preparation required for Impact Six-C. Just sit back and enjoy!

Want even more perks? How about the fact that while Impact Six-C prints at a resolution of 360 dpi, the addition of light cyan and light magenta delivers an image that is almost photographic? That means that even 14 point and reverse type come out super sharp. Sort of like the difference between decaf (yawn) and a double latté (olé!).

free refills

Think you might like a taste of six color printing? We warmly invite you to visit www.impactimaging.com to order a free, rather perky, door poster from our Winter 2000 Series. Each poster, printed on matte card, is a great sample of blazing Impact Six-C printing, not to mention, a great way to warm up your office.

And while you're there, learn more about Impact Imaging's quality and innovation in digital printing. You'll be able to download a selection of billboard templates, view samples of our work, request bids, and follow your job through our shop on a 24-hour, 7-days-a-week basis. So .com on by and see what all the buzz is about.

You don't ab scoop tho minutes with w job done, be.

!mpact

tami combs - regional sales manager

impact imaging, inc.
www.impactimaging.com

format digital printing!

creative firm
AND
art directors
Douglas Dearden,
Scott Arrowood
designer
Douglas Dearden
copywriter
Christy Anderson
illustrator
John Hersey
client
Impact Imaging

e old brew a fresh cup

A little side-by-side taste test

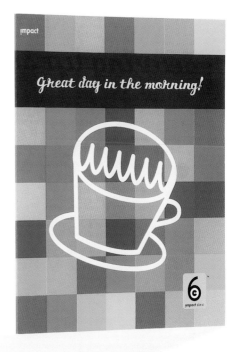

This Lance
Armstrong logo is
a bold silhouette
on a flag, with a
yellow bicycle
safety helmet, just
so you recognize the
top bike racer in the
world. Like Pele,
Lance is the only
name needed here.

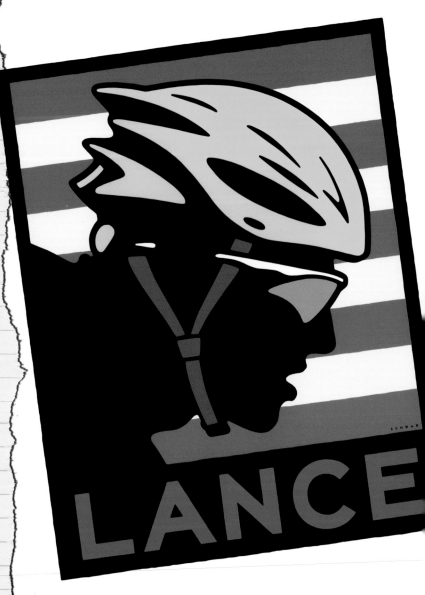

creative firm
Michael Schwab Studio
art director
Judi Oyama
client
Giro USA

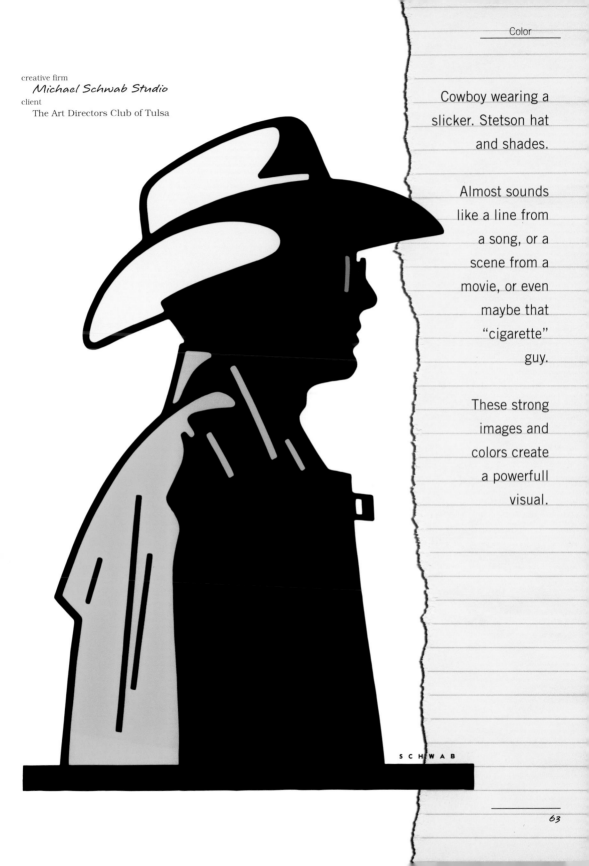

creative firm
Michael Schwab Studio
client
The Art Directors Club of Tulsa

Cowboy wearing a
slicker. Stetson hat
and shades.

Almost sounds
like a line from
a song, or a
scene from a
movie, or even
maybe that
"cigarette"
guy.

These strong
images and
colors create
a powerfull
visual.

SCHWAB

These four posters for Steppenwolf Theatre are all great examples of creative use of color.

"Homebody/Kabul" uses apparent blood splatters to command attention. The "Violet Hour" uses minimal bright color (on a dominant dark background) to focus your attention towards the window.

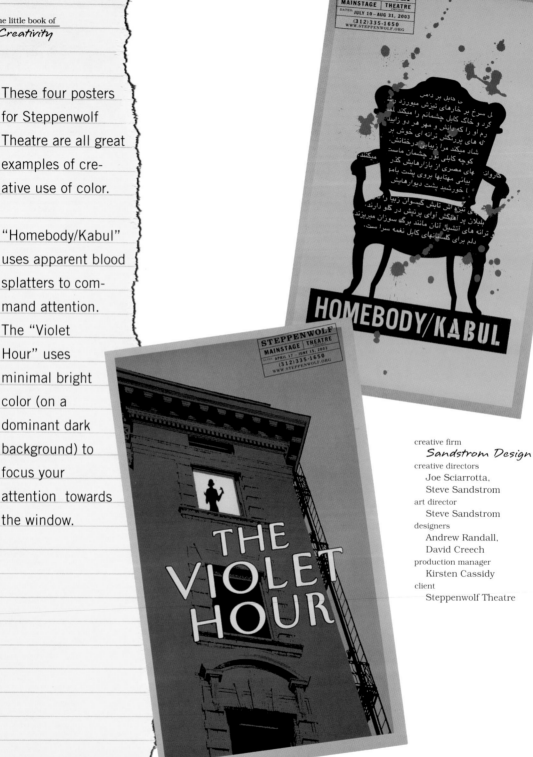

creative firm
Sandstrom Design
creative directors
Joe Sciarrotta,
Steve Sandstrom
art director
Steve Sandstrom
designers
Andrew Randall,
David Creech
production manager
Kirsten Cassidy
client
Steppenwolf Theatre

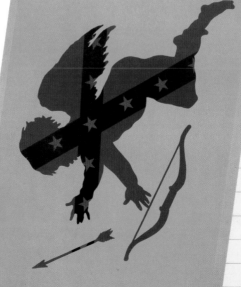

"The Time of Your Life" uses a single drop coming from a bottle—a heart-shaped drop, you will note—to grab the attention and make you wonder, "OK, what does that mean?" "Wedding Band" uses a falling cupid and a Confederate flag image to grab attention.

This package just *looks* clean and classy. The colors are as fresh as a morning shower, and the clearness of the product has an appeal that says "buy me."

creative firm
Out of the Box
art director
Rick Schneider
client
Mondria Personal Products

creative firm
Michael Schwab Studio
art director
Elma Garcia
client
Elma Garcia Films

The logo is black
and gray. Only the
eyes of the owl are
in another color.
Red eyes. That, you
can't forget.

E L M A

G A R C I A

F I L M S

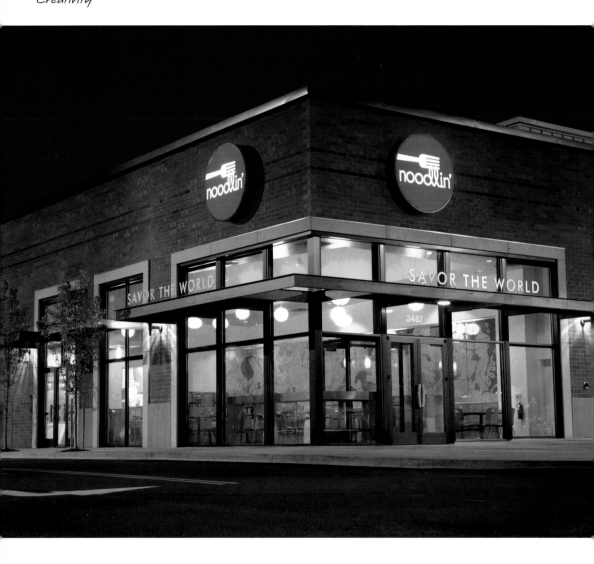

Noodlin' has environmental graphics that create a high energy level that makes you want to look and read.

The restaurant exterior features a well designed, yet simple red logo that invites you inside. Once there, the customer will see a large wall graphic, a mural tribute to the noodle. The "noodle-ology" makes for good reading, and entertainment, and stamps the Noodlin' brand name on your mind.

creative firm
Sandstrom Design
creative directors
Steve Sandstrom, Bill Borders
art director
Steve Sandstrom
designers
Steve Sandstrom, David Creech
production manager
Kirsten Cassidy
client
The Holland Inc.

The four logos here are used to illustrate creative use of color. The Thoughtstar design (nice use of think ballon with a star inside) is a single color, a fairly standard red. Yet, it's memorable because of its execution. The other three logos make good use of "out of the box" color use. The Noma design and the Wristgliders logos use colors that aren't often seen for logos. Message here: look at the entire color swatch spectrum.

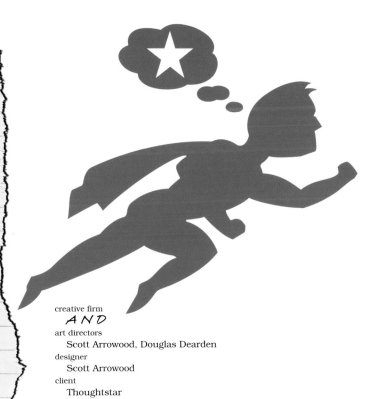

creative firm
 A N D
art directors
 Scott Arrowood, Douglas Dearden
designer
 Scott Arrowood
client
 Thoughtstar

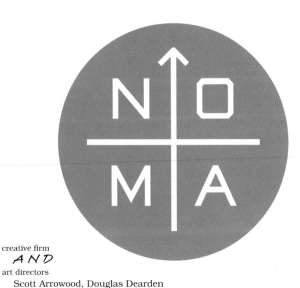

creative firm
 A N D
art directors
 Scott Arrowood, Douglas Dearden
designer
 Scott Arrowood
client
 NOMA (North of Main)

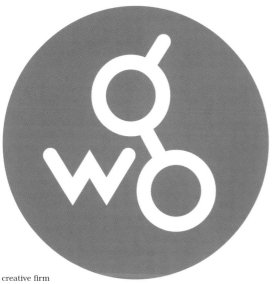

Finally, the Head Skis logo uses two colors quite effectively (and it also reproduces well as in black and white, which should be a major consideration in any logo project).

creative firm
AND
art director, designer
Douglas Dearden
client
Wristgliders

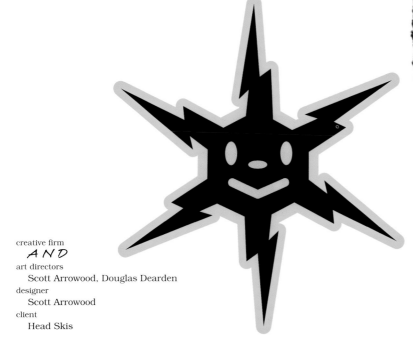

creative firm
AND
art directors
Scott Arrowood, Douglas Dearden
designer
Scott Arrowood
client
Head Skis

This black and white image is a yin/yang image that sticks in the mind. But white is really an off-white, and its use gives the logo a subtle difference that gives it additional distinctiveness.

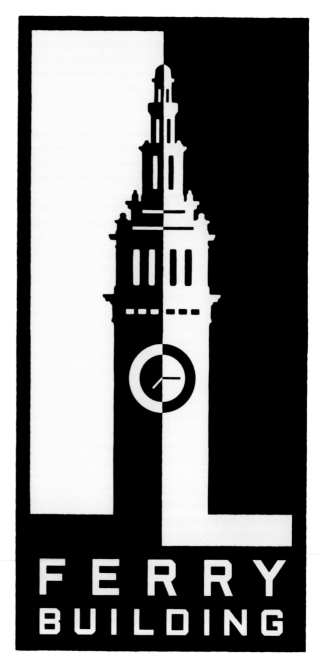

FERRY BUILDING

creative firm
Michael Schwab Studio
art director
Richard Springwater
client
Ferry Building Investors/Wilson Cornerstone

design firm
Out of the Box
art director
Rick Schneider
photographer
Paul Mutino
Client
Kasim Tea Ltd

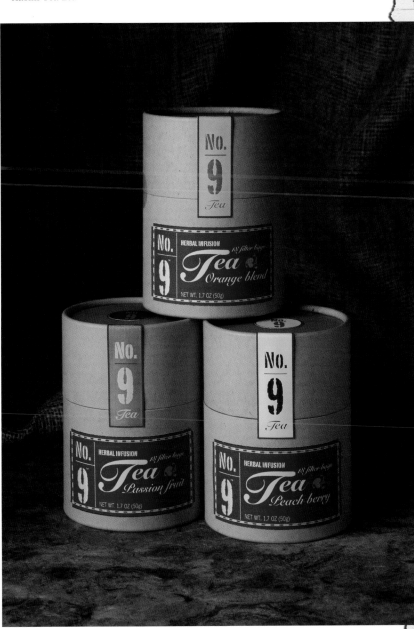

You go into a little store on a side street. They have tea for sale, but the proprietor sees that you are a true tea connoisseur. He says "Wait, I have something in the back that you might like." That's the kind of package this is. The colors, the layout, and the type give it a distinction that makes it memorable. You can almost taste it when you see the package.

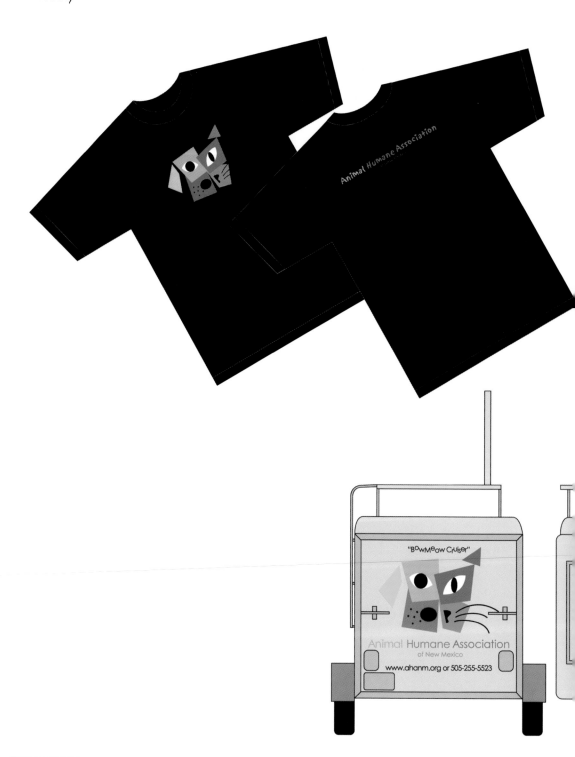

The applications
for the AHA
organization are
bright, happy, and
playful. The way
puppies and
kittens should be.

creative firm
Vaughn Wedeen
art director, designers
Pamela Chang, Rick Vaughn
client
Animal Humane Association
of New Mexico

Finding good homes for animals
is our pet project.

Animal Humane Association of New Mexico
We care for animals. www.ahanm.org or 505-255-5523

al Humane Association of New Mexico

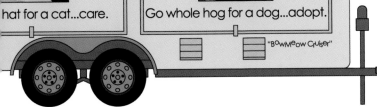

hat for a cat...care.

Go whole hog for a dog...adopt.

"BowMeow Cruiser"

Paint can project.
Make it unusual.
How about
black...nobody uses
black...and then put
the actual color of
the paint as a paint
streak. Attention
getting, and useful
in choosing the
product.

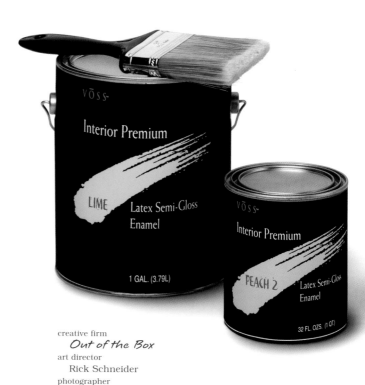

creative firm
Out of the Box
art director
Rick Schneider
photographer
Paul Mutino
client
Voss Paint Products

Creating packaging for a product such as shoe inserts could be a pretty boring project. It could be mind numbing, and the result could be a pretty bland design, one that blends into the other bland designs in this product category.

However, in the hand of highly creative people, the result can be bright, colorful designs that grab attention. The use of cartoon-like images makes the package interesting and very readable.

design firm
A N D Design
art directors
Scott Arrowood, Douglas Dearden
designer
Brian McDonough
copywriter
Christy Anderson
illustrator
Juliette Borda
client
Superfeet Dressfit Inserts

This poster promoting art in public schools is full of color. The design is quite professional, but also has a simplicity that is deceptive. The multiple layers of color attract the eyes of children and adults alike. One possible response: "Daddy, when I grow up, I want to be an artist."

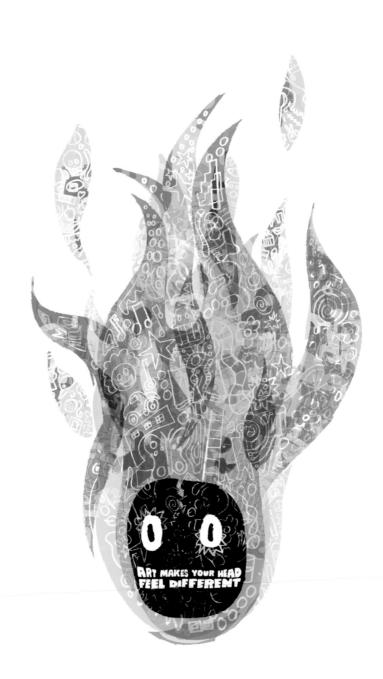

ART MAKES YOUR HEAD
FEEL DIFFERENT

creative firm
Henderson Bromstead
art director, designer
Hayes Henderson
designer, illustrator
Billy Hackley

creative firm
Out of the Box
art director
Rick Schneider
photographer
Ted Hallett
client
Aero Brewery

The beer "made for adventure lovers." Just close your eyes and think what that package design should be...and you might imagine the Aero Beer packaging. Cool. Hot. And very creative.

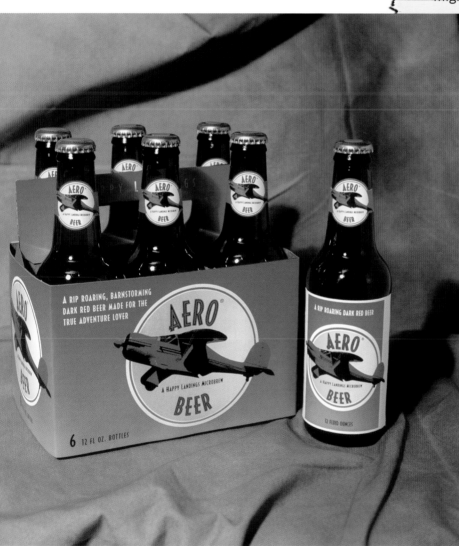

OK, you don't
think of Scotland
as the wine center
of the universe,
but this California
wine carries the
name MacLean,
in celebration of
the clan's long
heritage. The
simple tartan
plaid, capped by
matching red at
the top of the
bottle, gives this
package design a
simple elegance
that works.

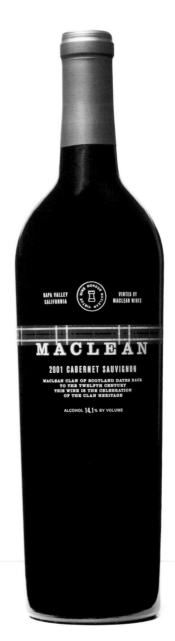

creative firm
Templin Brink Design
creative directors
 Joel Templin, Gaby Brink
designer, illustrator
 Brian Gunderson
client
 Target/Archer Farms

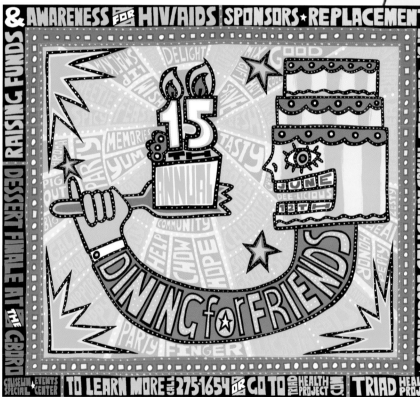

Step right up, Bring your dollars and… come to the Triad Health Project fund raiser. This fun piece grabs your attention, makes you smile, and hopefully, makes you want to help. Great solution, and the use of type and color is excellent.

creative firm
Henderson Bromstead
art director
Hayes Henderson
designer, illustrator
Kris Hendershott

This 2002 wrapping paper is also a creative showcase (and creative exercise). The colors are pseudo ink samples, and the names (karaoke blush, wet banana, mouldy cheese, and hypothermia) are just a few of the clever ideas shown on this piece.

creative firm
Viva Dolan
creative director
Frank Viva
designers
Frank Viva, France Simard,
Todd Temporale, Sarah Wu
copywriters
France Simard, Todd Temporale,
Sarah Wu, Doug Dolan, Frank Viva

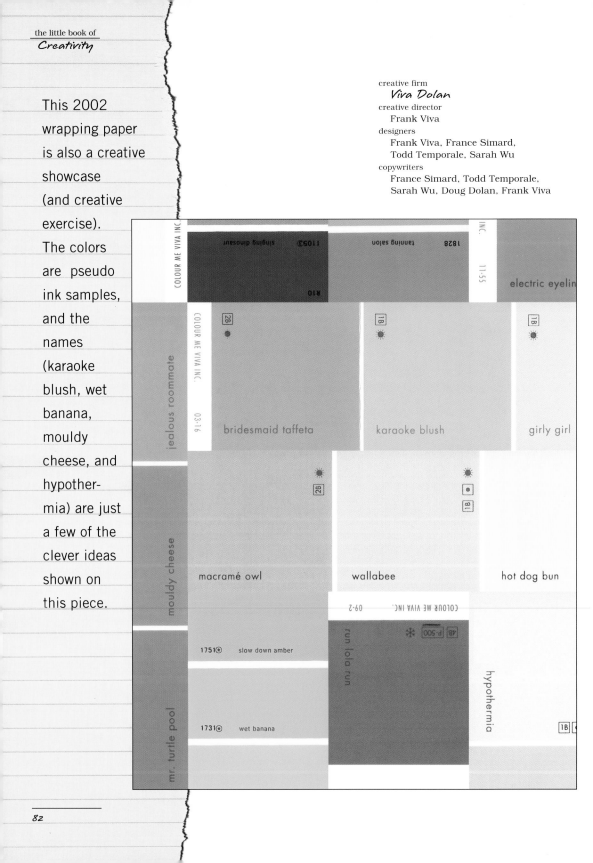

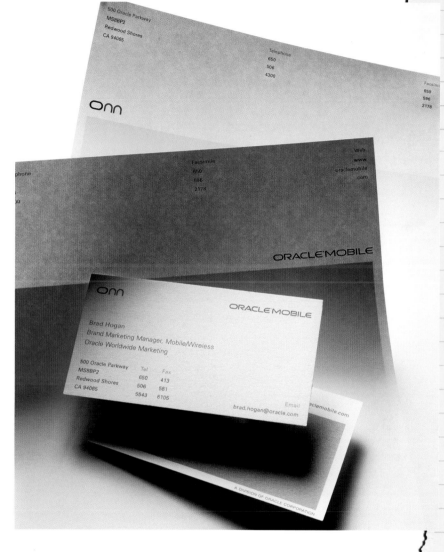

This letterhead set breaks the rules for corporate identity by having several different colors used in the system. Although the colors are different, the design consistency is still there in a very subtle, very effective way.

creative firm
Templin Brink Design
creative directors
Joel Templin, Gaby Brink
designer
Brian Gunderson
client
Oracle Mobile

This letterhead set has differing colors of paper and inks for the envelope and letterhead. Different, but related, spot illustrations are used as well.

creative firm
McGaughy Design
art direstor, designer
Malcolm McGaughy

DECISION · SUPPORT · SEARCH

COMPANY

DECISION · SUPPORT · SEARCH

COMPANY

18 YOGANANDA STREET · SANDY HOOK, CT 06482

8 YOGANANDA STREET · SANDY HOOK, CT 06482 · 203-426-1900 · FAX: 203-426-5773 · INTERNET: HTTP://WWW.DSSCO.COM

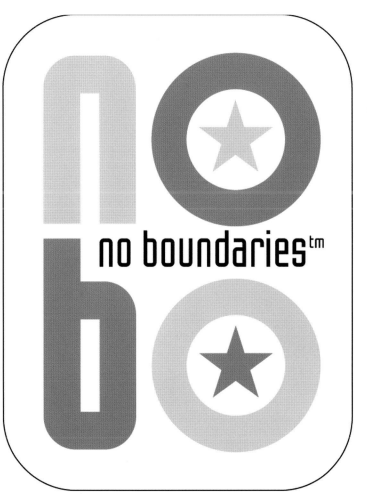

The logo for No Boundaries uses teal as the dominant color, but it is the use of the almost subtle gray that makes this piece jump out. And, the border uses rounded corners, the perfect edge to go with the rounded letters of the logo.

creative firm
Mires
creative director
Scott Mires
designer
Miguel Perez
client
Wal-Mart

creative firm
 Mires
creative director
 José Serrano
designer
 Mary Pritchard
illustrator
 Anja Kroencke
copywriter
 Eric LaBrecque
client
 Invitrogen

Using a very
striking graphic
techniqe, this
illustration fea-
tures people of an
indistinguishable
race.

The full solution provider.

A full range of choices within all product groups for every stage of the process. Superior choices at every stage. That's how we define full solution provider, and that's what we have worked hard to become. As your full solution provider, Invitrogen looks forward to providing the best possible technology and support at every stage of your project, in every respect.

This package uses a single-color theme most effectively. Highly memorable execution.

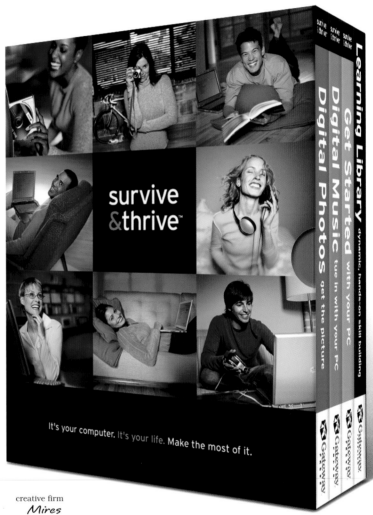

creative firm
 Mires
creative director
 John Ball
designer
 Jen Cadam
photographer
 Bill Zelman
copywriter
 Eric LaBrecque
client
 Gateway

This logo breaks the rules of design by having too many dark colors used adjacent to each other. But the overall effect is very eye-catching and presents a strong corporate identity.

creative firm
McGaughy Design
art direstor, designer
Malcolm McGaughy

The striking photos in these ads have several focal points. And though the ads are very different, the overall color of the photos instantly says "Visit Panama."

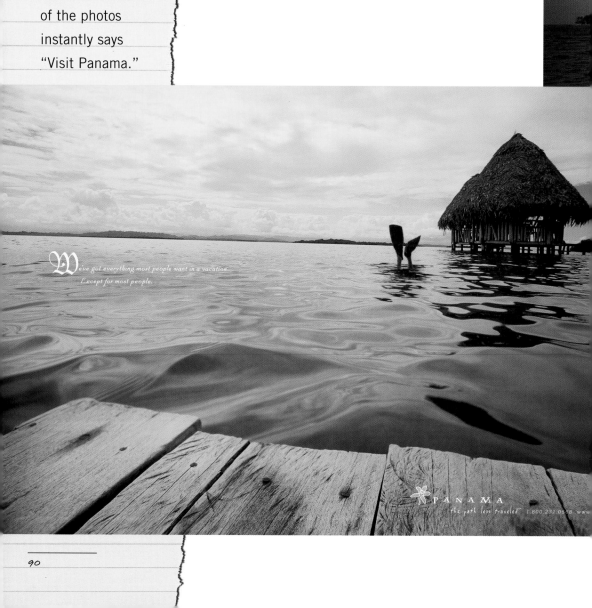

We've got everything most people want in a vacation.
Except for most people.

PANAMA
the path less traveled™ 1.800.231.0568 www.

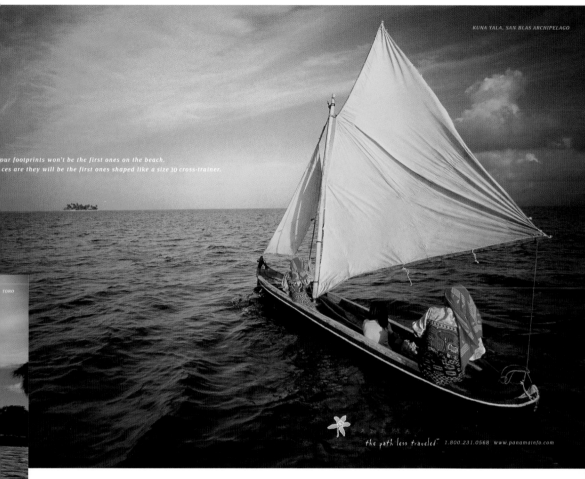

KUNA YALA, SAN BLAS ARCHIPELAGO

our footprints won't be the first ones on the beach.
ces are they will be the first ones shaped like a size 10 cross-trainer.

TORO

PANAMA
the path less traveled™ 1.800.231.0568 www.panamainfo.com

creative firm
BBDO Atlanta
creative director
Jim Noble
art director
Dave Stanton
copywriter
Carlos Ricque
photographer
Richard Hamilton Smith

The ultimate in cool. This jacket made of Zippo lighters shows style, class, and a classic brand.

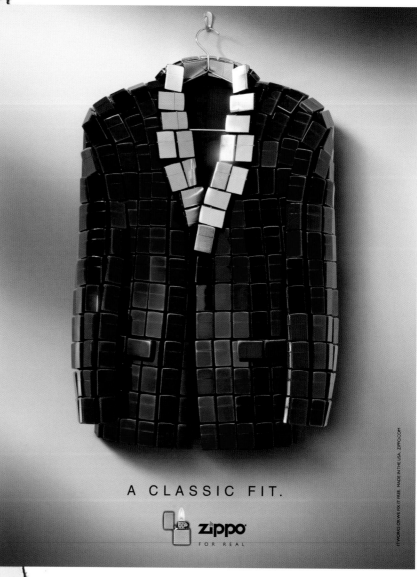

A CLASSIC FIT.

Zippo
FOR REAL

creative firm
Blattner Brunner
chief executive director
Bill Drake
creative director
Dave Vissat
associate creative director
Andy McKenna
photographer
Tom Gigliotti
client
Zippo

This ring binder could have been passed over as a small project, but in the creative world there are *no* small projects. The color and multiple images on the cover make this say "you should see what's *inside*."

creative firm
Cocchiarella Design

The green image jumps right at you, yet it is not over-powering. When a design firm creates its own identity, it better be good.

This one is.

creative firm
Vaughn Wedeen
art director, designer
Rick Vaughn
client
Gizmo

This interesting
spread grabs the eye
by using a sea of
color that could best
be described as
"banana yellow."

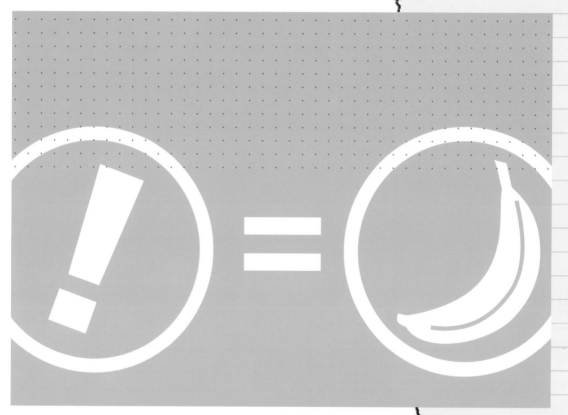

creative firm
Scheufele

This brochure for a printer uses color like most people have never seen. The graphic expressions of this piece says "we know color printing like few others."

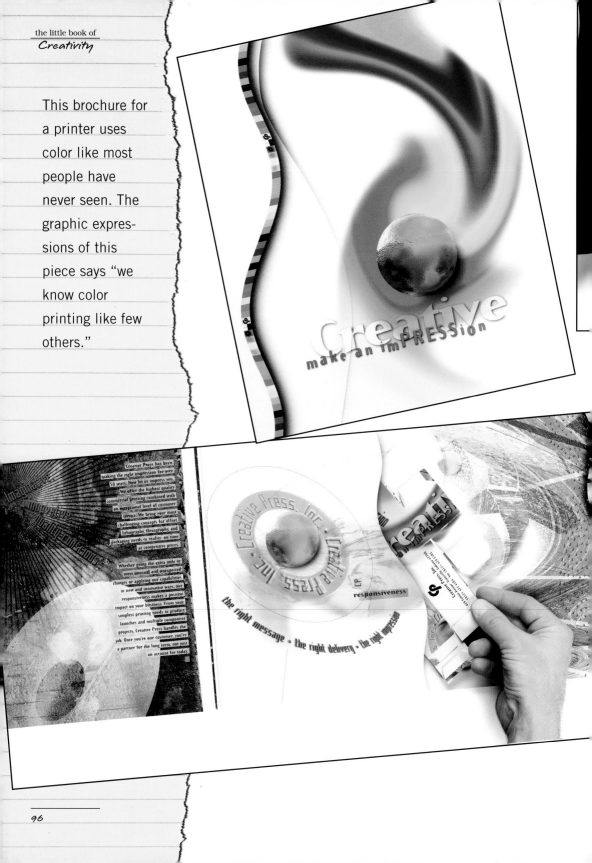

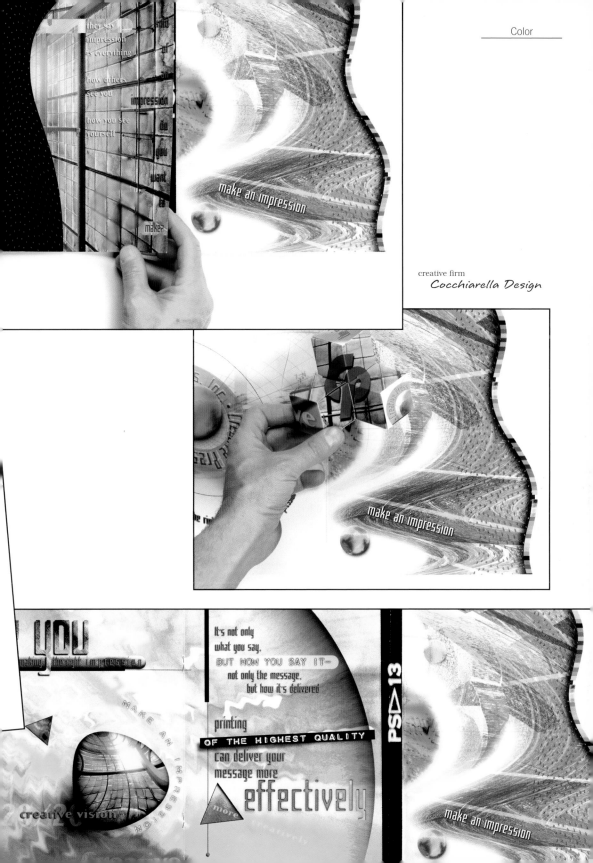

creative firm
Cocchiarella Design

The use of a white background strongly contrasts with the color making them seem bolder than they are. It is not only visually pleasing, but is also a great marketing tool to assure that the brand name is seen throughout the store, thus becoming very recognizable.

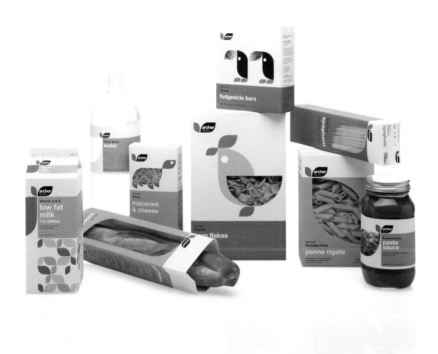

creative firm
Templin Brink Design
creative directors
Joel Templin, Gaby Brink
designer, illustrator
Brian Gunderson
client
Target/Archer Farms

Death to those who do not recycle!!! The Joan of Arc-like woman facing death is doing so on a background of...actual recycled paper. Simple, yet very creative.

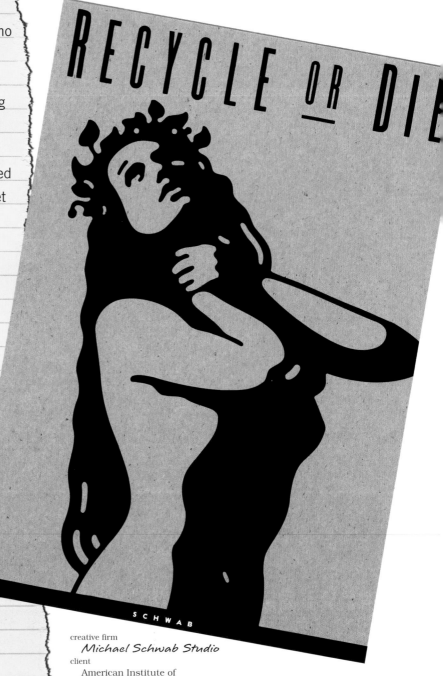

creative firm
Michael Schwab Studio
client
American Institute of
Graphic Arts

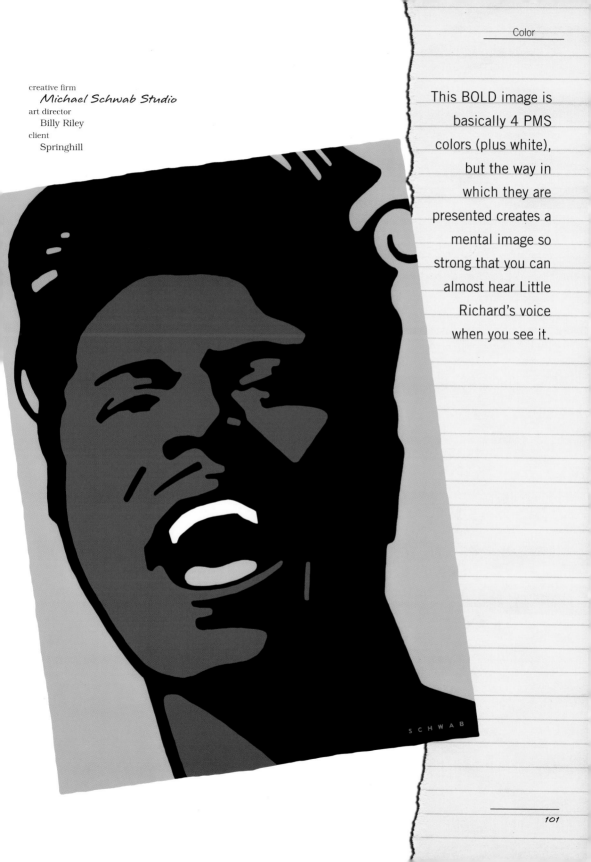

creative firm
Michael Schwab Studio
art director
Billy Riley
client
Springhill

This BOLD image is basically 4 PMS colors (plus white), but the way in which they are presented creates a mental image so strong that you can almost hear Little Richard's voice when you see it.

The good news: you just got a project to promote paper. The bad news: it **better** be good

High profile projects are major opportunities, but you can't afford anything but top quality work. This array of work makes good use of color, design, type and many other creative elements. All put together in a nice package.

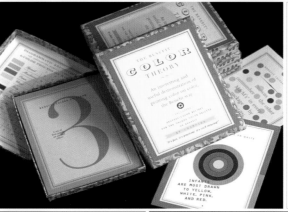

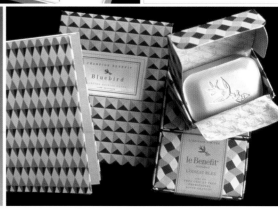

creative firm
Doyle Partners
designer
Lisa Yee
client
Benefit Paper

LAS VEGAS

LAS VEGAS

LAS VEGAS

The dimensionality of the poker chips is simulated in this memorable logo for Las Vegas.

creative firm
 Mires
creative director
 José Serrano
designer, illustrator
 Miguel Perez
client
 Las Vegas Chamber of Commerce

When the product
is new and
unique, the
packaging should
show it off in all
its dimensions.

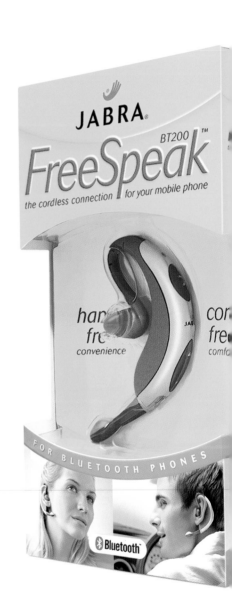

creative firm
 Mires
creative director
 John Ball
designer
 Miguel Perez
client
 Jabra

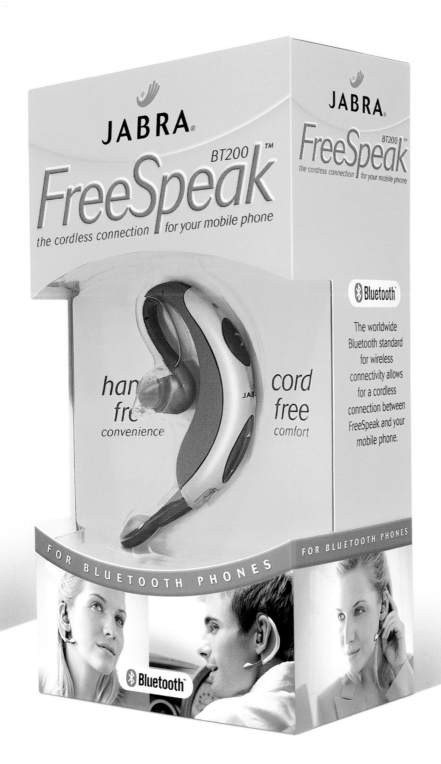

This logo has two layers of chocolate—dark and light—so well done that you can almost taste it.

BOCHNER
Chocolates

creative firm
Mires
creative director
José Serrano
designer
Miguel Perez
client
Bochner Chocolates

This design of this chemistry set takes you back to your 13th birthday, when you hoped you'd get one. And now, you did.

creative firm
Vaughn Wedeen
art director, designer
Steve Wedeen
client
US West

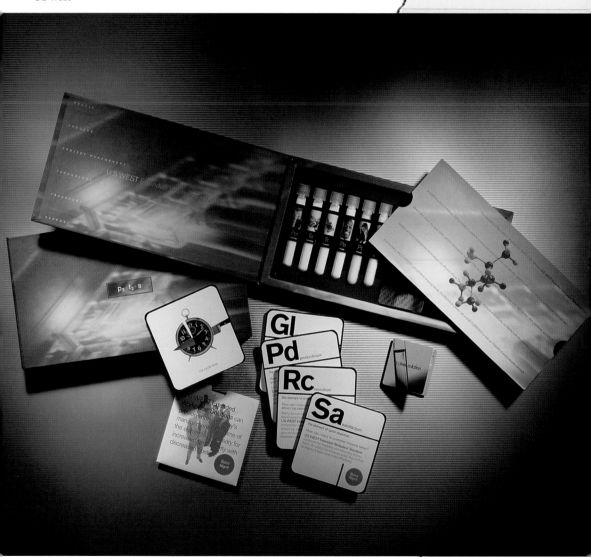

P E L I C A N

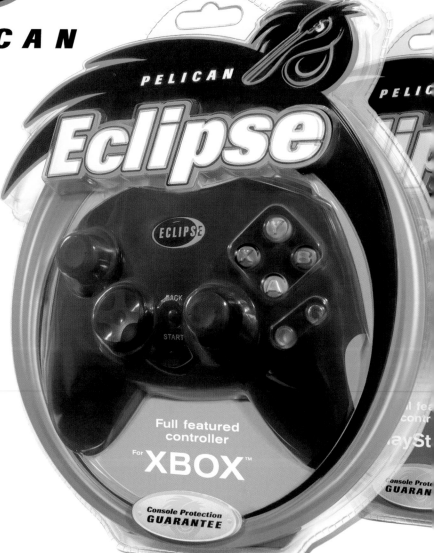

creative firm
Mires
creative director
John Ball
designer, illustrator
Miguel Perez
copywriter
Eric LaBrecque
client
Pelican Accessories

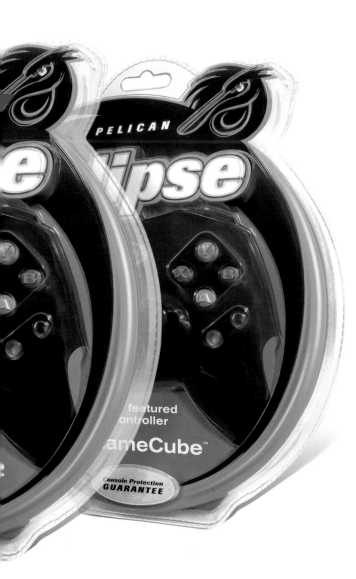

This design takes
the usual three-
dimensional pack-
age, and adds
another layer. It
almost simulates
the controls of a
video game. In
addition, the
pelican's head
extending beyond
the package's
round boundaries
contributes to the
dimensionality.

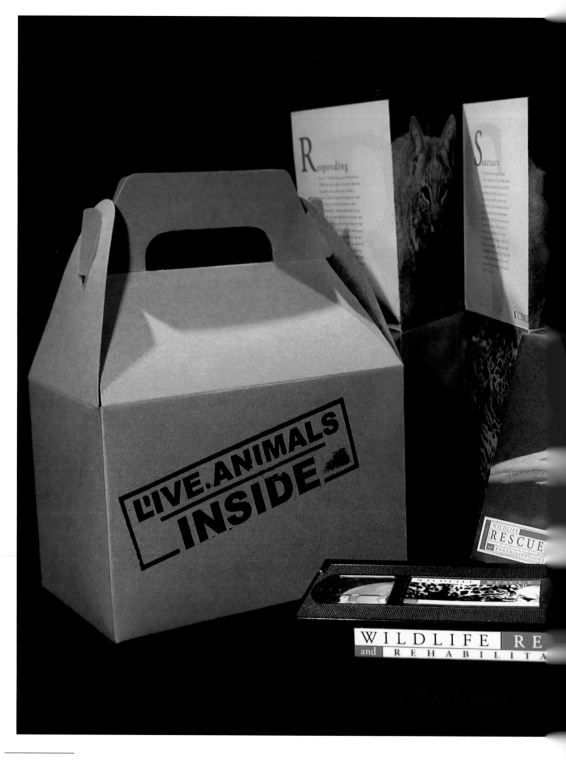

The cardboard box and the bold print stating "Live Animals Inside" immediately intrigues, and we must see what's inside. A video and pullout literature add to this nice dimensional piece.

creative firm
The Bradford Lawton Design Group
creative director
Bradford Lawton
art director, designer
Lisa M. Christie
client
Wildlife Refuge and Rehabilitation

This Ken Griffey, Jr. poster for Nike shoes has many creative elements going for it. The baseball is an immediate attention getter, but it's the layout that draws your eye through the piece. It's as if you are being led from element to element by the art direction of this ad. Oh, you ARE. This is Exhibit A of "how to do it."

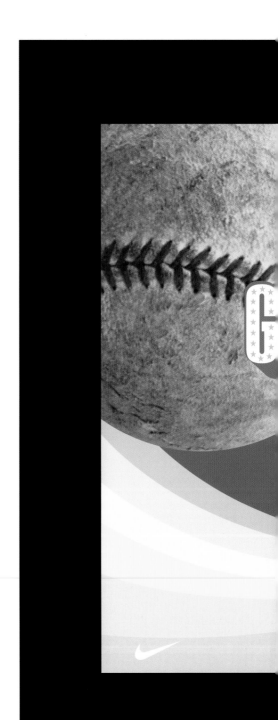

creative firm
Wink Inc.

THE CROSS-TRAINER

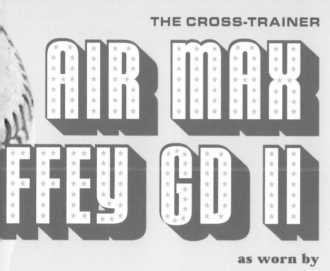

AIR MAX
FFEY GD II

as worn by

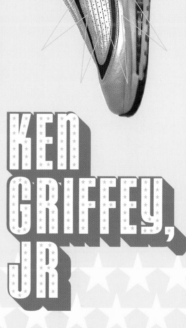

KEN
GRIFFEY,
JR

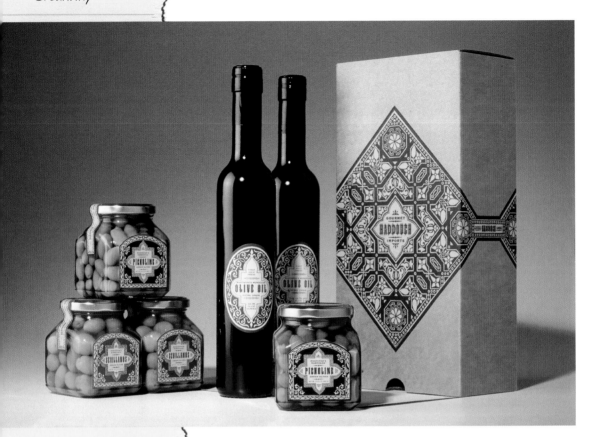

This product line has multiple incarnations: box, jar, and bottle. Each has its own rigid design parameters, yet the brand identity is used consistently throughout.

creative firm
TWIST inc.
designer, illustrator
 Kristine Anderson Dahms
photographer
 Rick Dahms
client
 Haddouch Gourmet Imports

creative firm
Templin Brink Design
creative directors, designers
 Joel Templin, Gary Brink
client
 Tomorrow Factory

The stationery set for the Tomorrow Factory looks more like yesterday, but that's part of the appeal. It has a manual typewriter font, but with a design that's quite modern in its layout.

The mixed images of this piece command attention and make it stand out from the typical letterhead set.

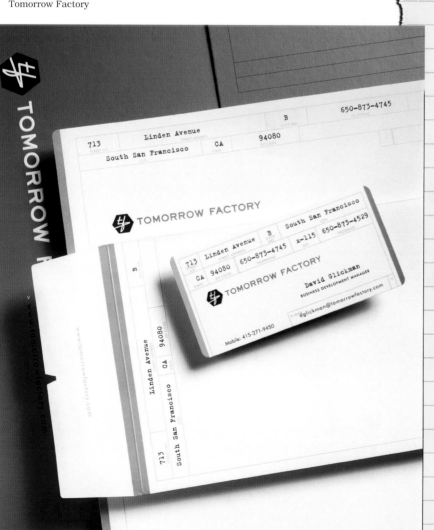

When multiple pieces are used for any client, creating visual consistency is a must. The graphic style of this unusual series is maintaining a variety of applications. The bold photo technique (showing Tiger Woods), com-bined with the powerful color combination, make this quite appealing.

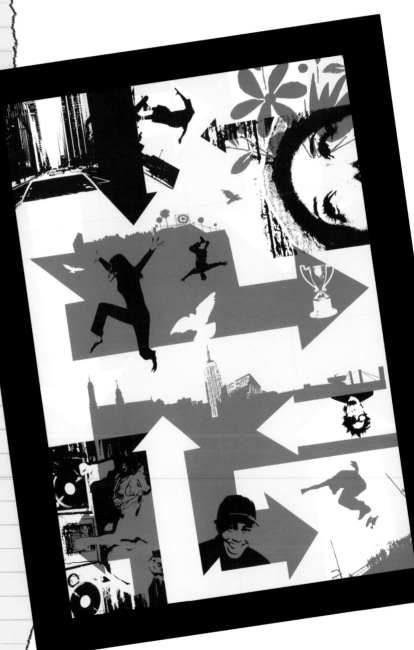

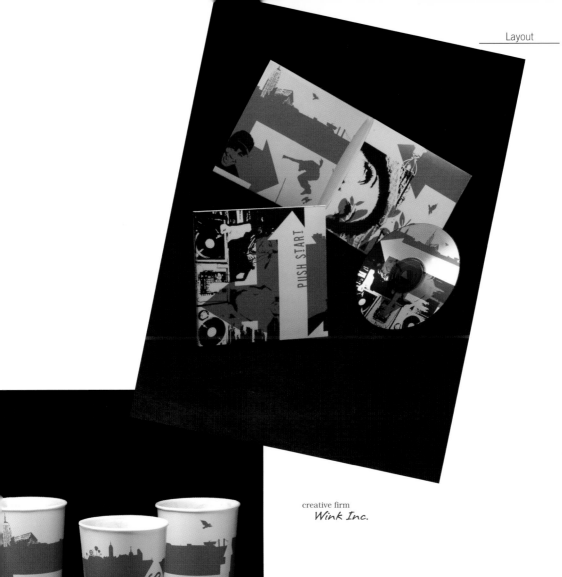

creative firm
Wink Inc.

The use of concentric circles is a visual treat. Note that the font includes circular O and A and C characters.

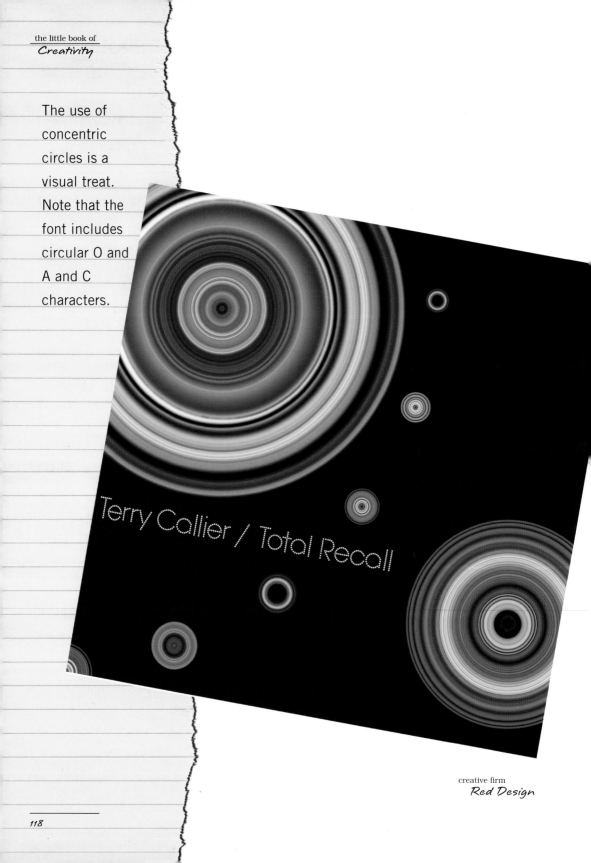

Terry Callier / Total Recall

creative firm
Red Design

This ad for a winery compares some very tragic events of 1945. And one very good event. It's a tongue in cheek ad that works well and is very memorable.

1945

Atomic bomb destroys Hiroshima.

Germany lies in ruins.

Soviets massacre Lithuanian rebels.

Cold War begins.

If only more years could turn out like this one.

Chateau Margaux Wines.

creative firm
BBDO Atlanta
creative director
Bill Pauls
art director
Jen Wells
copywriter
Mark Billows

That stamp. Is there music coming from it? Maybe. And the postage stamps below present an interesting contrast to the KISS stamp.

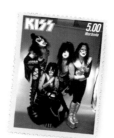

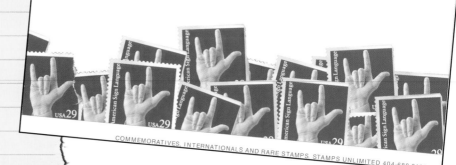

creative firm
BBDO Atlanta
creative director
Bill Pauls
art director
Lee Dayvault
copywriter
Matt Ledoux

The words "Super Collider" are the smallest element in this piece, but the layout and color draw your eye to it immediately.

creative firm
Red Design

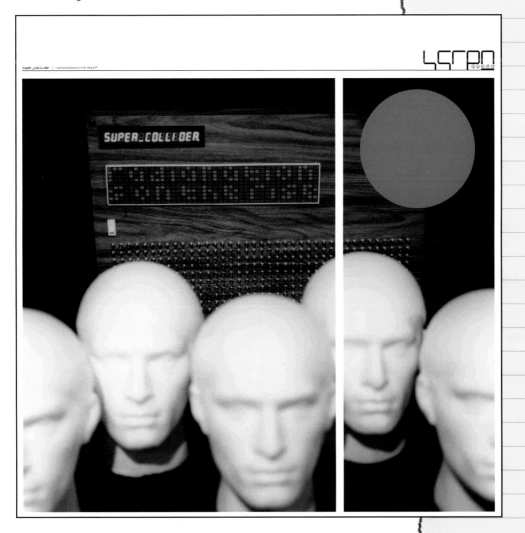

One trend in creativity that should have long-term staying power is the creation of a set of logos, all with a common theme and a common graphic style.

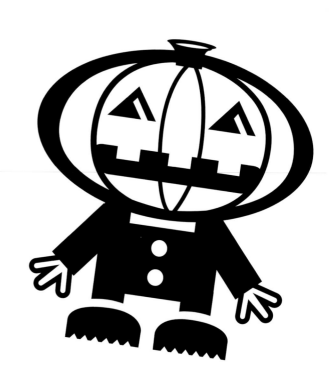

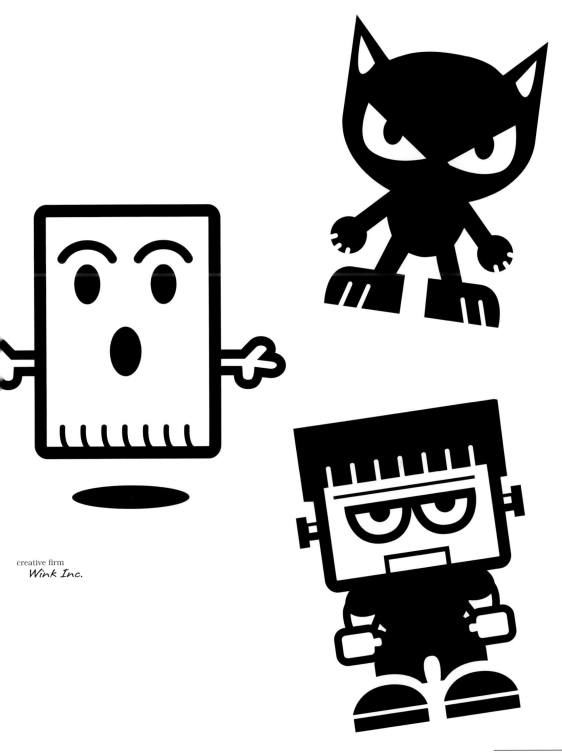

creative firm
Wink Inc.

Wow! Your eyes quickly scan over the cover—so much to see. Images that remind you of yesterday...and today. Color images mixed with black and white images...it works well here.

You can't stop looking, you can hardly wait to open the cover and look inside.
You're hooked.

Mission accomplished.

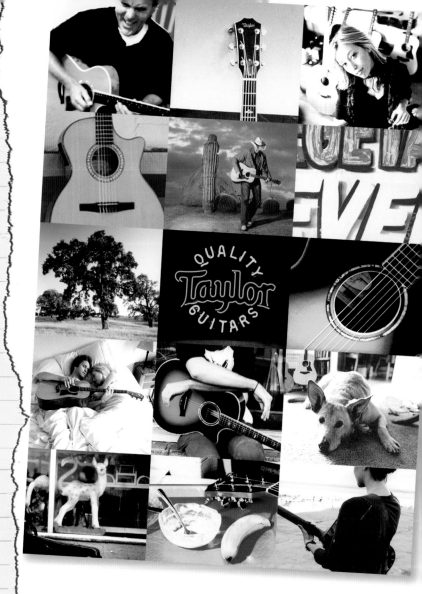

creative firm
 Mires
creative director, art director
 Scott Mires
art director
 Lois Harrington
designers
 Gale Spitzley, Mary Pritchard
photographer
 Marshall Harrington
copywriter
 Eric LaBrecque
client
 Taylor Guitars

creative firm
Lure Design
designer
Jeff Matz
client
Foundation

Lots of things about this design are very appealing; but it's the layout that makes it truly unusual. You see edges of other ads here, making you look longer, seeking an answer about what's happening. Then you gravitate back to the Yo La Tengo ad, with the lady who seems to have lost her head.

A Foundation Presents

Monday SEPT. 15th, 2003

YO LA TENGO

at The SOCIAL

$15.00

ALL AGES!
Tickets available at
Ticketmaster
Park Ave CDs and
Park Ave CDs UCF

Ad Club Awards competitions often give creative people a chance to show their stuff to their peers, and often, they miss their mark. This one scores a direct hit. The black and white simplicity has type that works, and the multiple pieces tend to set the categories apart, which the usual "omnibus" pieces don't do.

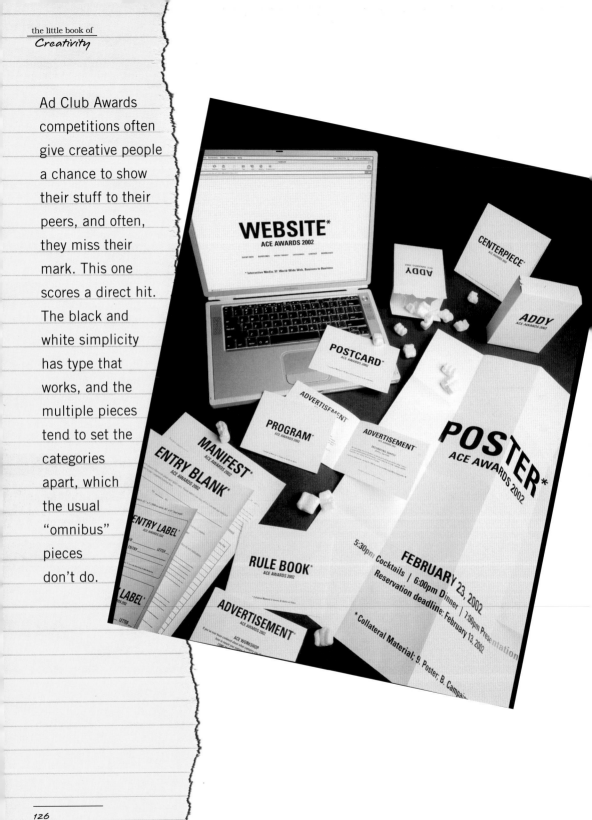

ADDY
ACE AWARDS 2002

creative firm
Cocchiarella Design

POSTER*
ACE AWARDS 2002

ADDY
ACE AWARDS 2002

RULE BOOK*
ACE AWARDS 2002

FEBRUARY 23, 2002
5:30pm Cocktails | 6:00pm Dinner | 7:00pm Presentation
Reservation deadline: February 13, 2002

Collateral Material: 9. Poster, B. Campaign

* Collateral Material

This
unusual
layout makes a
"we're very cre-
ative" design
statement about a
design firm.

creative firm
Cocchiarella Design

Many CD designs are unimaginative and pretty dull. This John Deere CD breaks the mold with a great photo from overhead.

creative firm
Cocchiarella Design

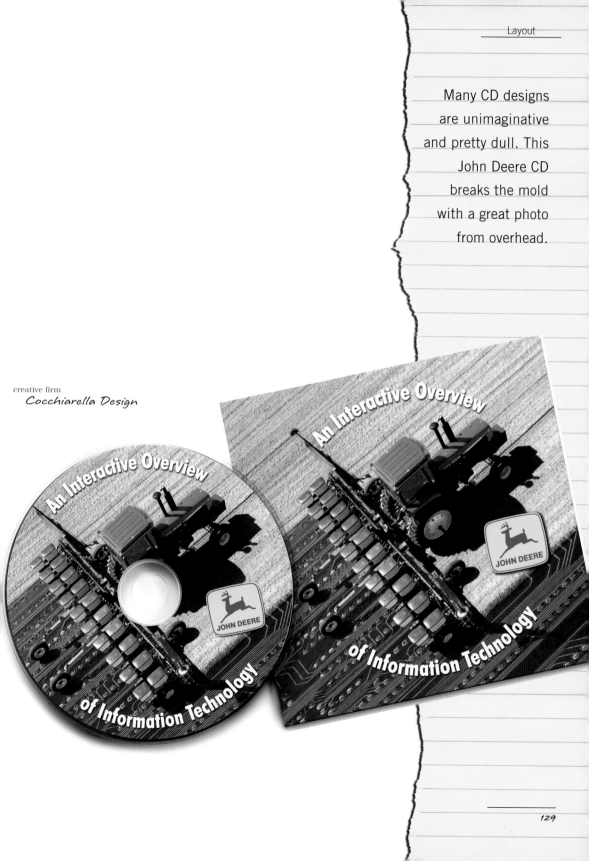

This CD uses a holographic technique to get two different images, depending on how you hold the piece. The technique is perfect for a CD titled "Look into the Eyeball".

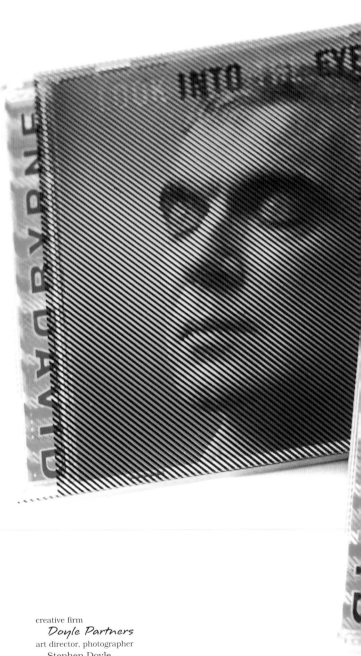

creative firm
Doyle Partners
art director, photographer
Stephen Doyle
designers
Ariel Apte, John Clifford
client
Nonesuch Records

There are many techniques available that can make the right project a winner. Catalog them in your mind and be ready when the right project comes along.

This poster for
the Addy
Awards shows
multiple images
from the adver-
tising world.
The colors give
a contrast that
make this a
high-energy,
appealing
poster.

creative firm
Henderson Bromstead
designer, illustrator
Hayes Henderson

The most creative
work draws the
audience into the
work. To a male
audience, this
appeal to go "half-
way between the
gutter and the stars"
is very inviting.

creative firm
Red Design

HALFWAY BETWEEN THE GUTTER AND THE STARS

These two images keep drawing the eye back, as the viewer goes to the many images on the piece. Photo manipulation offers many possibilities for creating visual excitement. This is an excellent example of how to do it.

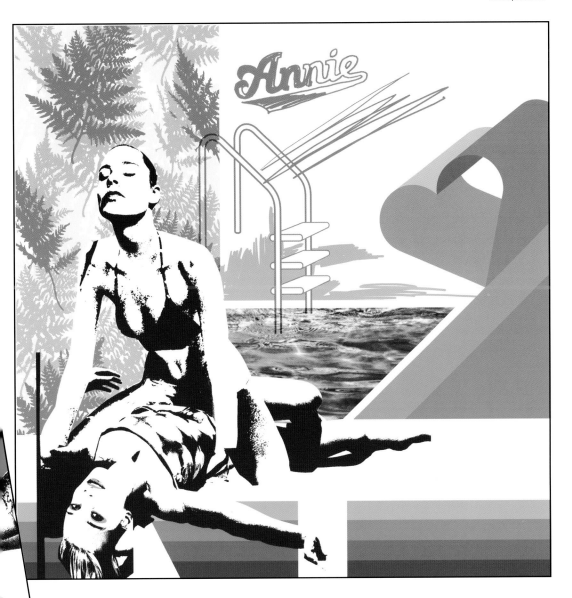

creative firm
Red Design

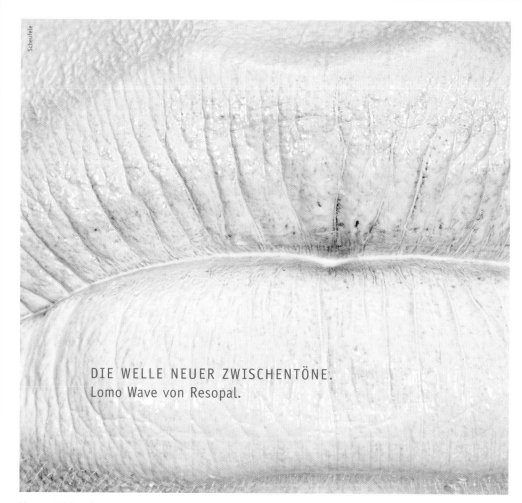

DIE WELLE NEUER ZWISCHENTÖNE.
Lomo Wave von Resopal.

Die menschliche Wahrnehmung wird zum großen Teil durch unterbewusste Töne und Schwingungen gesteuert. In diesen Zwischen-
tönen liegen subtil versteckte Impulse, die unsere Sinne anregen. Lomo Wave von Resopal verstärkt diese Wirkung durch eine
horizontal verlaufende Wellenstruktur, bei der trotz metallischer Anmutung warme Klangfarben durchschimmern. **See me.
Feel me. Hear me. Lomo Wave von Resopal – das übernatürliche Material.**

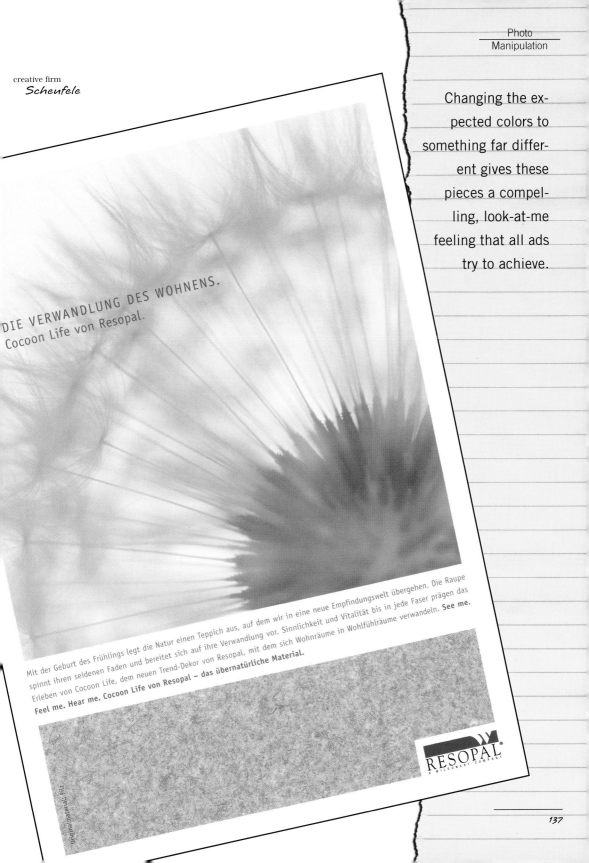

creative firm
Scheufele

Changing the ex-
pected colors to
something far differ-
ent gives these
pieces a compel-
ling, look-at-me
feeling that all ads
try to achieve.

DIE VERWANDLUNG DES WOHNENS.
Cocoon Life von Resopal.

Mit der Geburt des Frühlings legt die Natur einen Teppich aus, auf dem wir in eine neue Empfindungswelt übergehen. Die Raupe spinnt ihren seidenen Faden und bereitet sich auf ihre Verwandlung vor. Sinnlichkeit und Vitalität bis in jede Faser prägen das Erleben von Cocoon Life, dem neuen Trend-Dekor von Resopal, mit dem sich Wohnräume in Wohlfühlräume verwandeln. **See me.**
Feel me. Hear me. Cocoon Life von Resopal – das übernatürliche Material.

RESOPAL®
A WIESONART COMPANY

This piece recalls
the paper dolls and
clothes from child-
hood. The modern,
computer-era
version here, cap-
tures and holds the
attention of card-
carrying adults.

creative firm
Red Design

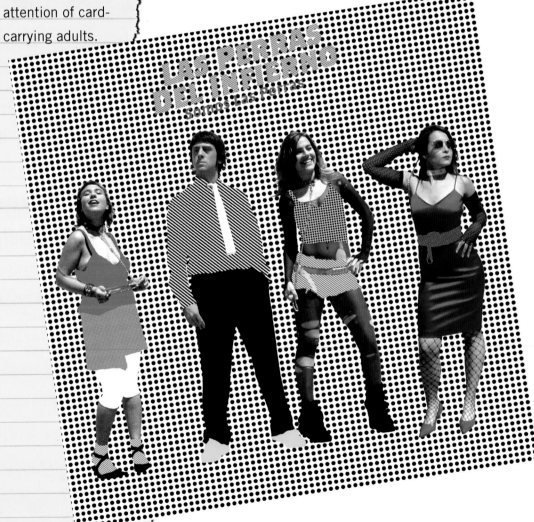

creative firm
Arnika
art director
Michael Ashley
copywriters
Dinseh Kapoor, Matt Fischvogt
client
Babe Ruth Museum and Birthplace

This tribute to base-
ball player Cal Ripken
uses photo manipula-
tion to remove the
player from the photo
and replace it with a
shadow. The symbol-
ism creates a very
compelling image.

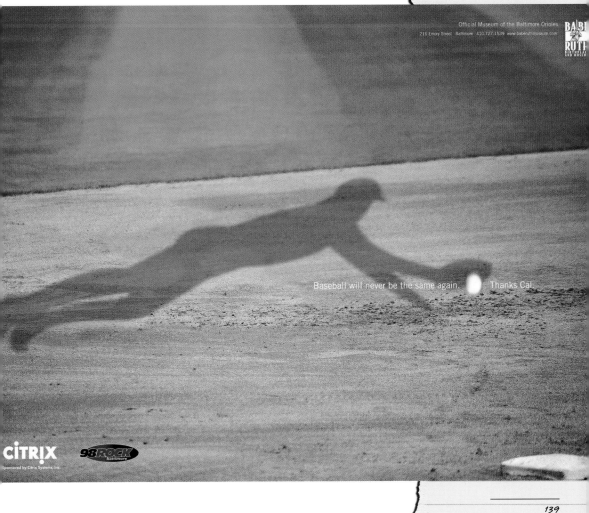

Official Museum of the Baltimore Orioles
216 Emory Street Baltimore 410.727.1539 www.baberuthmuseum.com

BABE
RUTH
BIRTHPLACE
AND MUSEUM

Baseball will never be the same again. Thanks Cal

CITRIX
Sponsored by Citrix Systems, Inc.

98 ROCK
baltimore

10, 2003
EN AT 8PM! SHOW AT 9PM!

ONETTES

RR at THE SOCIAL

TENS FOR CHRISTIAN

NCUT! UNCENSORED!
UROPEAN VERSION!

TICKETS AVAILABLE
PARK AVE CDS / PARK AVE CDS UCF
AND TICKETMASTER

$10

POSTER BY LURE DESIGN

This design is
reminiscent of the
1950s horror
movies.

Or the 1950s bad
girl movies.

Or the teenage
motorcycle gang
movies.

Or all three.

The typography as
well as the colors
used make this an
appealing promotion
for a concert.

creative firm
Lure Design
designer
Jeff Matz
client
Foundation

The headline grabs your attention immediately.

Then you see the stack of wood.

The type, the illustrations, the layout, and the logo all say "way back when."

Combine those factors with the headline that says "read me" and you have a powerful ad.

By the way, most hardware ads are really bad.

This one is great.

CHOOSING A WOODEN LEG THAT'S RIGHT FOR YOU.

Paris. Milan. New York City. Richmond. You don't have to be some big city free mason to know that wood never goes out of style.

For centuries, wooden legs have been found in the most dapper social circles. After all, they're beautiful and sturdy. And who doesn't like talking about wooden furniture?

Maybe you're the flashy oak type. Or you like the power and prestige that comes with maple. Or the simple style that comes with pine.

We've got just the wood to match your personality.

Nothing turns heads like the right wooden leg.

And your kitchen. And dining room. And your front porch.

We've got plenty of wood to choose from. And if you already have your own wood, we've got all the tools you'll need to cut, carve, whittle, sand, and buff your way through high society.

Not to mention power tools, drills, chair caning, imported hand tools, antique Williamsburg furniture brasses, carbide shaper cutters and bits, specialty wood finishes, and plenty of other American-made products.

And most importantly, we offer expert advice. Because we love wood as much as you do. And we can help you through the biggest and the smallest of projects when you're ready.

HARPER HARDWARE
1712 E. Broad St., Richmond

creative firm
Arnika
art director, copywriter
Michael Ashley
client
Harper Hardware

A "how to" ad for a hardware store. Good start.

But then the headline evokes an image of a cartoon character sitting on a limb, sawing off the limb, and about to fall.

This series uses retro imagery as well as snappy copy to create a most memorable corporate image.

HOW TO HOLD A SAW WHEN REMOVING A LIMB.

No matter what you're sawing, get a grip. Be resolute. And don't change your mind mid-project.

First, you make sure you've got a lot of chloroform handy. And a saw. And a couple of seaworthy helpers who won't keel over at the sight of a little blood.

OK, a lot of blood.

Prior to the Civil War, there were roughly 14,000 physicians in America.

And out of that number, only 527 had actually 'performed' surgery before. So there were a lot of shaky hands performing the 30,000+ amputations that had to be performed during the war.

And so it went that surgery and the world of hardware essentially went

'Sawbones' like George Otis performed one amputation every 15 minutes some days.

hand in hand.

Saws, hammers, screws, pliers and other not so pleasant sounding remedies were used to the same ends — to save lives.

Today, we're out of the first aid business. But we're still there for all those less painful projects and services with a large selection of rental equip-

ment available, power tools, chair caning, imported hand tools, antique Williamsburg furniture brasses, carbide shaper cutters and bits, and specialty wood finishes. All made here in the U.S. of A.

And most importantly, expert advice.

Because we're not some fancy hardware with neon designer smocks and electric doors. And we never will be.

HARPER HARDWARE
1712 E. Broad St., Richmond

The headline makes you focus on just two of the thousands of reasons to get the blues.

You almost begin singing the "George Washington's got wooden teeth, and not only do they hurt, but they make him pretty much un-kissable" blues song.

The retro look draws you in. The copy inspires you to buy a ticket.

creative firm
Arnika
art direstors
Michael Ashley, Bill Lee
copywriters
Dinseh Kapoor, Matt Fischvogt
client
Boys and Girls Club of America

WHO GETS THE BLUES WORSE?

The man with wooden teeth or the woman that kisses him?

BLUES IN THE 'BURG

Saturday, September 22 · For more info call Shellie Ridder @ 540-785-6472
Tickets available through www.TicketWeb.com · Uptown at Central Park
Benefits the Boys and Girls Club of Greater Washington, Fredricksburg Regional Branch

creative firm
Lure Design
designer
Jeff Matz
client
Wilco

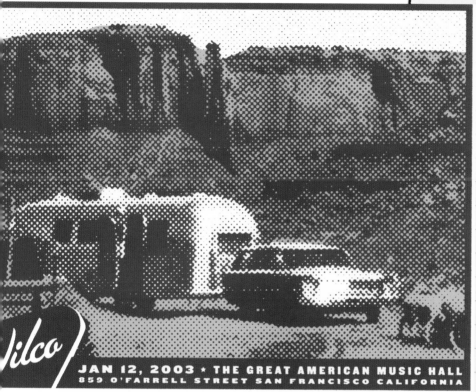

The rounded pull-it-behind trailer is straight from the Lucille Ball—Desi Arnaz 1950s movie "Long, Long Trailer." And the Grand Canyon setting is straight from a 50's "See America" promotion. The large dot pattern reinforces the retro image and creates a powerful image.

Budget Note: This is a two-color printing job, so the creators got a lot of bang for the client's buck.

creative firm
Arnika
art director
Michael Ashley
copywriter
Chris Thompson
client
Mark and Jay's Big and Tall

"You know, Mickey, a sports jacket with the sleeves rolled up says 'Look at me, I'm from France'."

"Amen Dick."

... but the one and only Dickies™ work pant, so come on down to a real man's store like Mark's &Jay's in Hopewell and pick yourself up a pair. 5294 Oaklawn Blvd

The color of the backgrounds evokes memories of the ads from men's magazines of the 1950s such as Argosy, True Detective, and other barbershop reads.

The whimsical copy and excellent use of white space make these ads visually interesting, and at the same time, easy to read.

Let Wilco put you in the driver's seat. This poster is reminiscent of the Hertz Rent-A-Car TV commercials from the 1950's (the flying driver was put into a moving car). Creative people are finding that what once worked will work again. This time, with a different twist.

creative firm
Lure Design
designer
Jeff Matz
client
Wilco

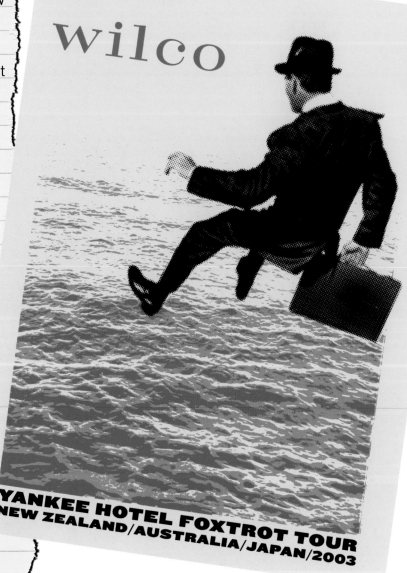

creative firm
Sandstrom Design
creative directors
Steve Sandstrom, Sally Morrow
art director
Sally Morrow
designer
Shanin Andrew
client
Converse

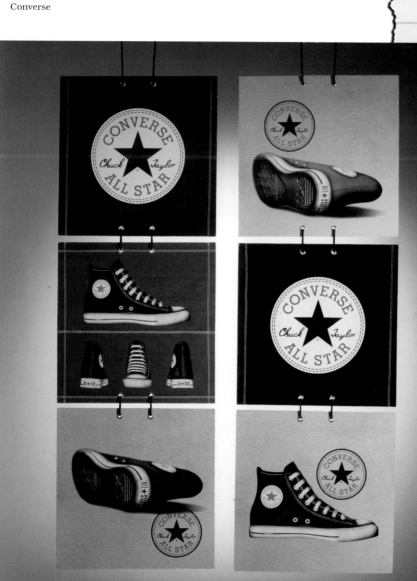

Converse All-Stars bring a warm feeling to the hearts of millions of "boomers" all over America. Before Nike, before Reebok, Converse was "the" shoe of choice for aspiring jocks.

The retro look appeals to a dual market: the black canvas makes the promotion stand out just that much more.

What is it about these pieces that grabs the attention? Is it the flower backgrounds? Is it the minimalist white drawings that stand out from the sea of color? Or is it the contrasting colors themselves that pull it all together?

GET OVER IT (3:16)

Lot of knots, lot of snags,
Lot of holes, lot of cracks, lot of crags.
Lot of naggin' old hags,
Lot of fools, lot of fool scum bags.
Oh it's such a drag, what a chore...
Oh your wounds are full of salt.
Everything's a stress and what's more,
Well it's all somebody's fault.

Hey! Get over it!

Makes you sick, makes you ill,
Makes you cheat, slipping change from the till,
Had it up to the gills...
Makes you cry while the milk still spills.
Ain't it just a bitch? What a pain.
Well it's all a crying shame.
What left to do but complain?
Better find someone to blame.

Hey! Get over it!

Got a job, got a life,
Got a four-door and a faithless wife.
Got those nice copper pipes,
Got an ex, got a room for the night.
Aren't you such a catch? What a prize,
Got a body like a battle axe.
Love that perfect frown, honest eyes,
We ought to buy you a Cadillac.

Hey! Get over it!

DON'T ASK ME (2:46)

Quit acting so friendly.
Don't nod, don't laugh all nicely.
Don't think you'll upend me.
Don't sigh, don't sip your iced tea.
And don't say, "It's been a while..."
And don't flash that stupid smile.

Don't ask me how I've been.

Don't think I've forgotten,
You never liked that necklace,
So cordial, so rotten.

Kiss, kiss, let's meet for breakfast.
Don't show up so on time
And don't act like you're so kind.

Don't ask me how I've been.

Don't sit there and play just
So frank, so straight, so candid,
So thoughtful, so gracious,
So sound, so evenhanded.
Don't be so damn benign
And don't waste my blasted time.

Don't ask me how I've been.

YOU'RE SO DAMN HOT (2:36)

I saw you sliding out the bar.
I saw you slipping out the back door, baby.
Don't even try and find a line this time, it's fine.
Darling, you're still divine.

You don't love me at all,
But don't think that it bothers me at all.
You're a bad-hearted boy trap, baby doll, but you're...
You're so damn hot.

So now you're headed to your car.
You say it's dinner with your sister, sweetie.
But darling look at how you're dressed,
Your best suggests another kind of guest.

You don't love me at all,
But don't think that it bothers me at all.
You're a bad-hearted boy trap, baby doll, but you're...
You're so damn hot.

So who's this other guy you've got?
Which other rubes are riding hotshot, sugar?
I could have swore you said before, "No more, for sure."
What'd I believe you for?

You don't love me at all,
But don't think that it bothers me at all.
You're a bad-hearted boy trap, baby doll, but you're...
You're so damn hot.

creative firm
Sagmeister

6. SHORTLY B

How long di
Who could h
But before w
Sing us a so

Who would t
A pink and s
Even as we
Sing us a sc

7. RETURN (3

Now it's yea
And even m
All gravel ar
But who nee
Displaced th
The worst o
I can't reme

Return.

For awhile,
We were aliv
The void too
But years ta
Antiseptic a

Return.

You were se
Reckless, ur
You were se

Return. Your

Perhaps it's all of these. Creativity knows no boundaries, and using multiple techniques to grab the mind is the way to avoid commonplace solutions.

8. THERE'S A FIRE (3:49)

ast?
w past?

s of dying.
ch a show?
?
rs of dying.

and dull,

ere,
bent into shape.
ur face.

Stop getting me off track.
I mean it, there's a problem here.
This time it is for real...
How can I make myself more clear?

I never say quite what I mean,
And never mean quite what I say,
And how did that get out of me,
And what the hell did I mean to say?

This time it is for real.
This is a real emergency.
This time I swear it is the truth...
This must be dealt with urgently.

I never say quite what I mean,
And never mean quite what I say,
And how did that get out of me,
And what the hell did I mean to say?

There's a fire. There's a fire.

I really mean it now.
This time I swear I have not lied.
This isn't like the last time...
I swear to God I have not lied.

I never say quite what I mean,
And never mean quite what I say,
And how did that get out of me,
And what the hell did I mean to say?

There's a fire. There's a fire.

The logo looks like it was taken from *Look*, or *Collier's* or any other 1950's mass-circulation magazine. And from a budget standpoint, the design can be reproduced using just two colors.

creative firm
Wink Inc.

creative firm
Sandstrom Design
creative directors
Steve Sandstrom, Sally Morrow
production manager
Ann Riedl
art director
Sally Morrow
designer
Shanin Andrew
client
Converse

Dr. J was probably the best player in the history of the NBA. Not only is the product and the look retro, so is the spokesman. Very creative, especially in the era of multi-gazillion dollar endorsement contracts for current superstars. (If you have to ask "who's Dr. J?" then you probably wouldn't understand the answer.)

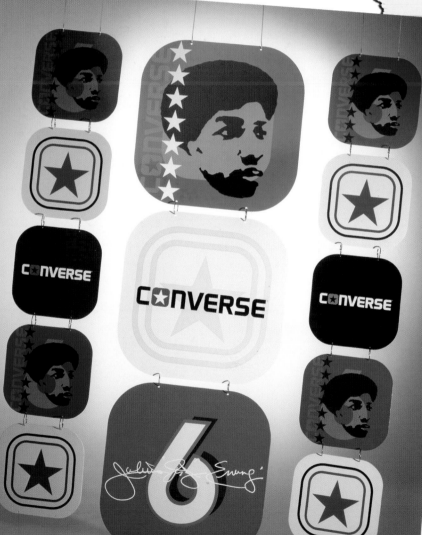

Turner Classic Movies are all about retro. So it's only natural that this calendar for TCM would include a retro look. Better still, go with the movie posters that were originally created for these great movies. Sometimes, it's a good idea **not** to reinvent the wheel. Especially when the original inventions (old movie posters) are so great.

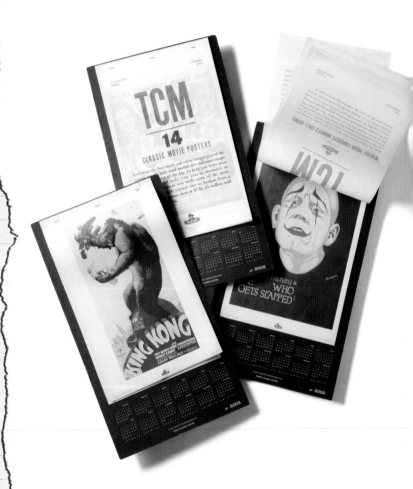

creative firm
Templin Brink Design
creative directors
Joel Templin, Gaby Brink
designer
Joel Templin
copywriter
Lisa Pemrick
client
Turner Classic Movies

This poster is almost a tribute to Alfred Hitchcock films and posters. The close-up of the frightened women, the exaggerated dot pattern and the bold type of the main title make this a poster not to be ignored.

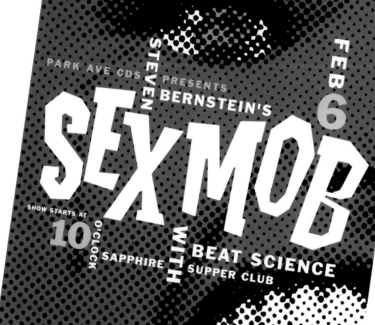

creative firm
 Lure Design
designer
 Jeff Matz
client
 Figurehead Productions

This CD design uses retro style. Retro, in this case, meaning late 60s, early 70s. The type, design style, and colors set the mood to an exact moment in time.

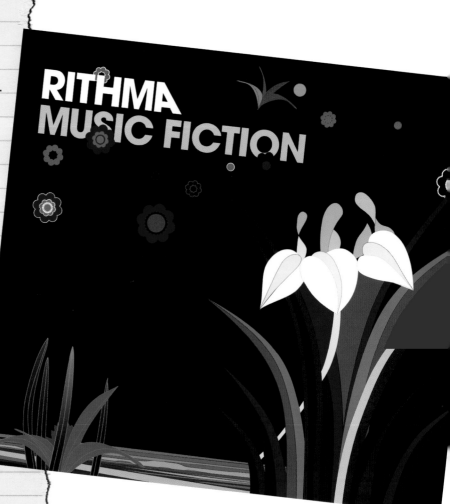

creative firm
Red Design

creative firm
Lure Design
designer
Jeff Matz
client
Wilco

The old portable typewriter is literally on fire. (Must be a really hot copy-writer?) The retro artwork pulls you into the flames and the 3-D-like, type images keep you there. Two-color magic on a budget.

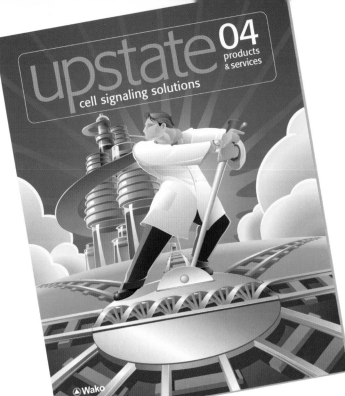

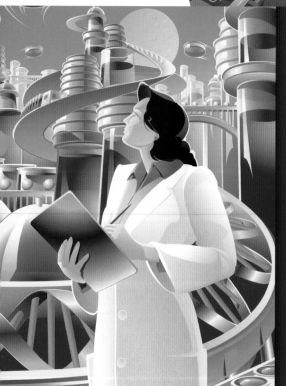

welcome to
cell signaling
central

If you are looking for the definitive source for cell
signaling products and services, you've come to the
right place. Wherever major advances in cell signaling
and drug discovery are taking place, chances are you'll
find Upstate. Upholding our commitment to provide
researchers with the most comprehensive and advanced
selection of tools to drive their cell signaling research
forward, we are pleased to introduce hundreds of
new products this year.

You will find a large number of new kinases as well
as the antibodies for these kinases and their substrates.
Our Kinase Profiler® specificity testing service now
features 85 kinases—15 more than last year. In addition,
we now offer a variety of service levels for turnaround
in as little as one week. Building on our Profiler family
of assays, we have added the P1 Profiler for P 1-3
kinase screening.

We have also expanded our line of Beadlyte® kits
and reagents for Luminex® detection systems, providing
more products for the multiplex analysis of cell signaling
proteins as well as new kits for cytokines, chemokines
and growth factors.

Take note, too, of our continued expansion into
products for chromatin research. We are proud to
support this and every other dynamic new frontier of
discovery, and to earn the trust of the scientists behind
the most significant cell signaling initiatives today.

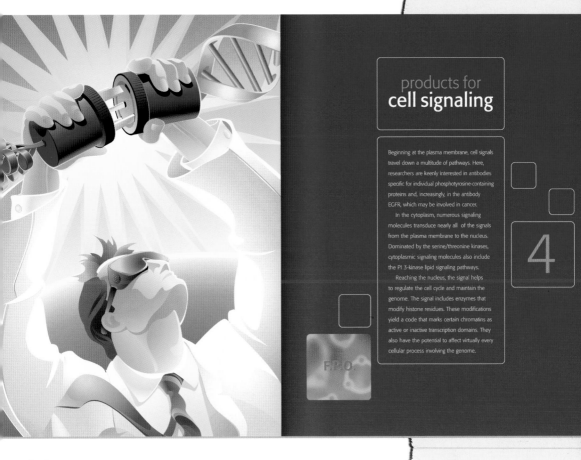

products for
cell signaling

Beginning at the plasma membrane, cell signals travel down a multitude of pathways. Here, researchers are keenly interested in antibodies specific for individual phosphotyrosine-containing proteins and, increasingly, in the antibody EGFR, which may be involved in cancer.

In the cytoplasm, numerous signaling molecules transduce nearly all of the signals from the plasma membrane to the nucleus. Dominated by the serine/threonine kinases, cytoplasmic signaling molecules also include the PI 3-kinase lipid signaling pathways.

Reaching the nucleus, the signal helps to regulate the cell cycle and maintain the genome. The signal includes enzymes that modify histone residues. These modifications yield a code that marks certain chromatins as active or inactive transcription domains. They also have the potential to affect virtually every cellular process involving the genome.

4

F.P.O.

creative firm
Mires
creative director
José Serrano
designers
Paulina Montrobio,
Kathy Carpentier-Moore,
Mary Pritchard
photographer
Carl Vanderschuit
copywriter
Eric LaBrecque
client
Upstate

This brochure has a "machine age" look that is appealing. (And interesting—the "machine" that was a tool used in its creation is a 21st century computer.)

"Hey big boy, pick me up and...smoke me."

You're going to like it. You're going to get hooked and cough a lot and...wait. Read the warning label and you see that this is a poster for a play. And most likely, the theater will be non-smoking.

Powerful execution of a one-color piece that looks like it stepped out of a 50's magazine.

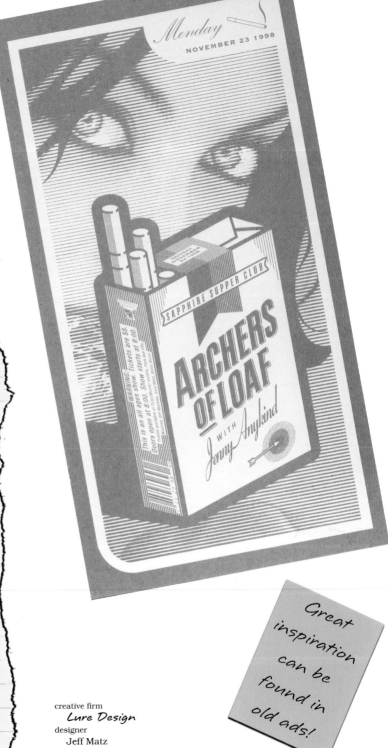

creative firm
Lure Design
designer
Jeff Matz
client
Figurehead Productions

Great inspiration can be found in old ads!

These related logos
are all something of
a "futuristic retro"
look. What's that
again? They have the
appearance of the
future, as seen back
in the 1950s, and
the style creates a
nostalgic look all
its own.

creative firm
Wink Inc.

When the theme is about restoration of "classic" cars, the very photos themselves are going to be retro. The use of the photo inside the photo on the one spread is highly effective.

MUSCLE

Woods Litho: An Insider's Look

Wheels. Remember how badly you wanted them back in high school? I do. But back then I couldn't afford a car. So maybe you can understand how I wanted to go back and recapture my youth. At some point I decided I wanted to restore a car, and I found myself thinking about the cars I wanted to cruise around in back then.

creative firm
Mires
creative director
Scott Mires
designer
Jen Cadam
photographer
Marshall Harrington
client
Woods Lithographics

MUSCLE CARS

What better way to celebrate the Kennedy Space Center's 40th Anniversary than with a trip down memory lane? These postcards remind us of the "Welcome to..." series of postcards used in the 40s and 50s.

Memories of Sci-Fi television, the "Cold War" and your favorite Major Matt Mason action figure come flooding back as the choice of colors not only gives a retro effect but also reminds us of those great movie posters from the same era.

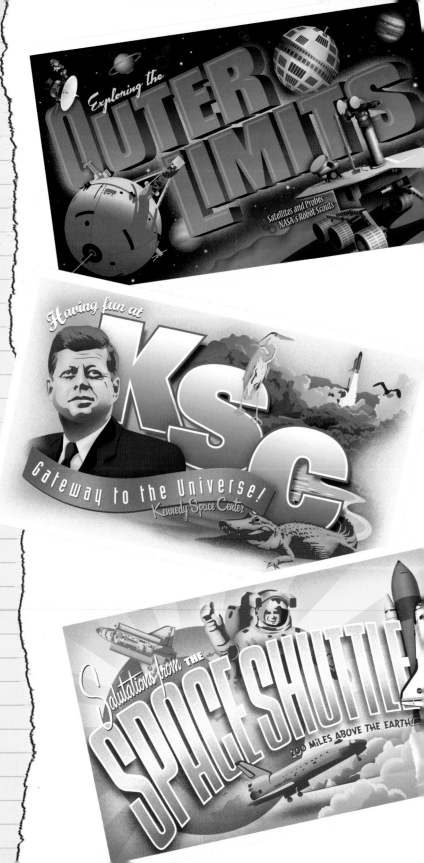

creative firm
**The Bradford Lawton
Design Group**
creative director
Bradford Lawton
art director
Rolando G. Murillo
designers, illustrators
Rolando G. Murillo,
Jennifer Z. Murillo,
Jason Limón,
Leslie Magee
client
Delaware North Park
Services of Spaceport, Inc.

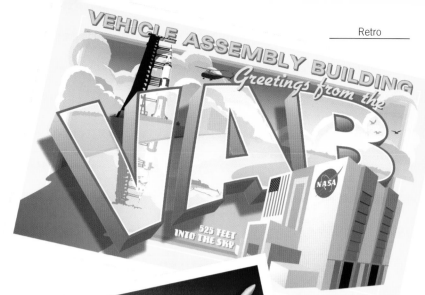

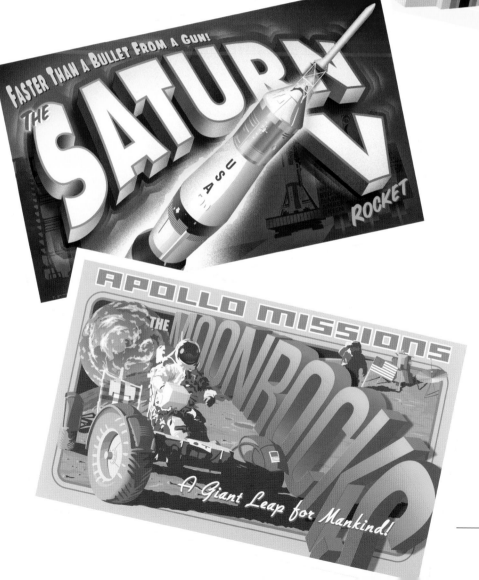

Henry V takes on a
different visual
meaning with a
city under seige
by enemy aircraft.

creative firm
Lure Design
designer, illustrator
Paul Mastriani, Jeff Matz
client
Orlando UCF Shakespeare Festival

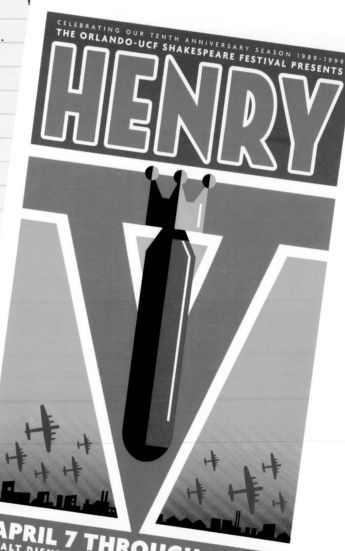

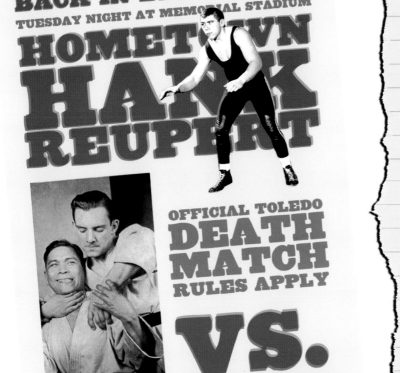

BACK IN BALTIMORE
TUESDAY NIGHT AT MEMORIAL STADIUM

HOMETOWN
HANK
REUPERT

OFFICIAL TOLEDO
DEATH
MATCH
RULES APPLY

VS.

THE TAPEI
TORTURER

brought to you by baltimore's beer. go hank!

creative firm
Arnika
art director, copywriter
Michael Ashley
client
Clipper City Brewing

The first words "Back in Baltimore" set the agenda: bring back an image of times past.

This poster uses type, design and photos to evoke the memory of the 1950s when wrestling on TV was even bigger than it is today. Yes, it's true, as they say, you can look it up.

The very size of the promotion is what first grabs you. It's not a poster, not a booth, but a walk-through exhibit that promotes ESPN. The visual experience inside is all ESPN, and very overwhelming.

The typographic treatment is an additional creative element that makes this work very well.

creative firm
Sandstrom Design
creative directors
Steve Sandstrom, Sally Morrow
art director
Sally Morrow
designers
Shanin Andrew,
Kristy Adewumi, David Creech
production managers
Ann Riedl, Kelly Bohls
client
ESPN

This isn't your usual map. It's billboard size. And to really catch the attention, there is a life-size ski lift that's headed toward the destination: Keystone. Powerful attention getter.

creative firm
 Cultivator Advertising&Design
creative directors
 Tim Abare, Chris Beatty
designers
 Chris Beatty, August Sandberg
copywriter
 Tim Abare
client
 Keystone Resort

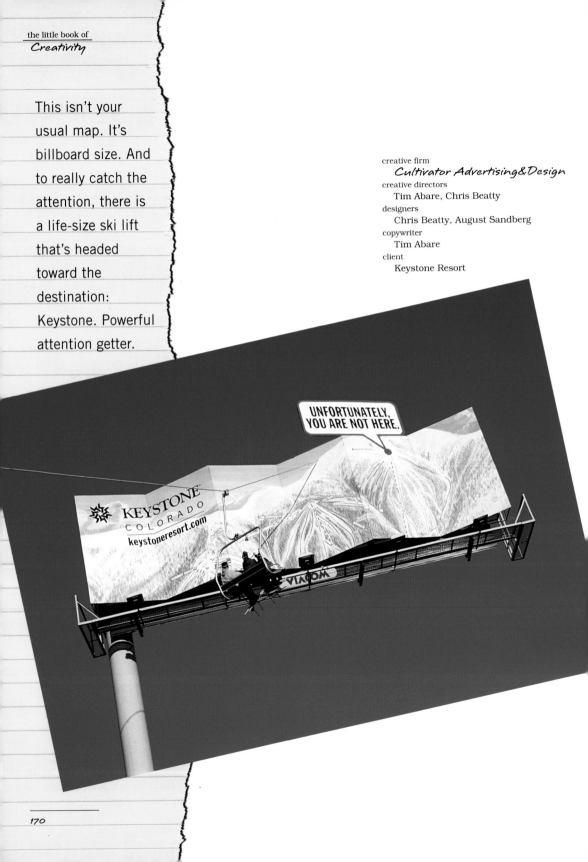

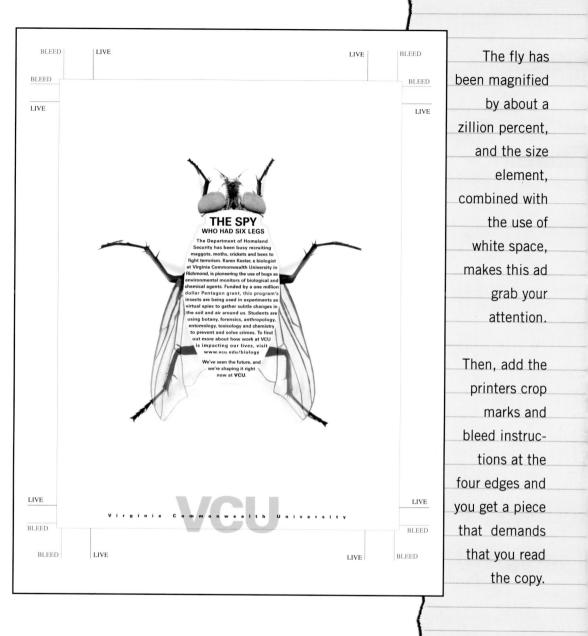

The fly has been magnified by about a zillion percent, and the size element, combined with the use of white space, makes this ad grab your attention.

Then, add the printers crop marks and bleed instructions at the four edges and you get a piece that demands that you read the copy.

THE SPY
WHO HAD SIX LEGS

The Department of Homeland Security has been busy recruiting maggots, moths, crickets and bees to fight terrorism. Karen Kester, a biologist at Virginia Commonwealth University in Richmond, is pioneering the use of bugs as environmental monitors of biological and chemical agents. Funded by a one million dollar Pentagon grant, this program's insects are being used in experiments as virtual spies to gather subtle changes in the soil and air around us. Students are using botany, forensics, anthropology, entomology, toxicology and chemistry to prevent and solve crimes. To find out more about how work at VCU is impacting our lives, visit www.vcu.edu/biology

We've seen the future, and we're shaping it right now at VCU.

Virginia Commonwealth University

VCU

creative firm
Arnika
designer
Diana Tung
copywriter
Dinesh Kapoor
client
Virginia Commonwealth University

This huge bottle cap looks like a beer ad. Then, you see it's an ad for the 5th anniversary of the B-B-Q Bar.

The magic words "free food and booze" are at the bottom.

We'll be there.

THANKS FOR FIVE GREAT YEARS!

creative firm
 Lure Design
designer
 Jeff Matz
client
 Bar BQ Bar

design firm
Out of the Box
art director, photographer
Rick Schneider
client
4 Square Pet Products

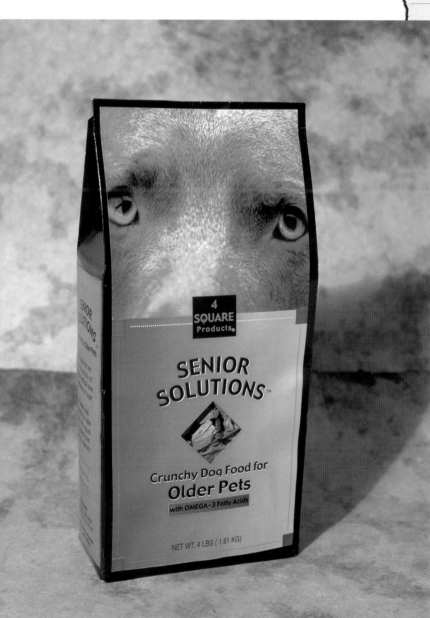

The dog is looking you right in the eye. The dog's eyes are pretty much full sized, and you are seeing "older pets" and you decide your dog fits into that category, and those big eyes are saying "bring me some home—some crunchy dog food." The big eyes made it happen.

Size counts.

The size of this bug—this very dead bug—is what gets your immediate attention.

Combine that start with a floating graphic and headline in a sea of white space, and you have an ad that demands attention.

The logo at the bottom is simple, and the message is clear: Want dead bugs? Call us.

SOME ORLANDO RESIDENTS ARE UP IN ARMS ABOUT OUR SERVICE.

Middleton
LAWN & PEST CONTROL
www.middletonpest.com

creative firm
Push
art directors, copywriters, creative directors
Ron Boucher, Gordon Weller, John Ludwig
client
Middleton Lawn & Pest Control

design firm
Out of the Box
art director
Rick Schneider
photographer
Ted Hallett
client
Kona Beverages

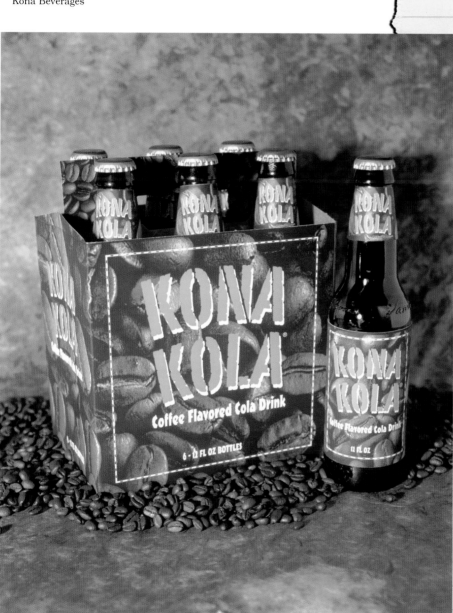

This coffee-flavored cola drink has a rich brown, coffee bean package design. The size of the beans on the package just jump out at you. Can you taste the cola? In your mind, you almost can.

Great execution.

creative firm
TWIST inc.
designer, illustrator
Kristine Anderson Dahms
photographer
Rick Dahms
client
Haddouch Gourmet Imports

And the winner of the Longest Neck on a Bottle Award: Argan Oil. This very thin, very elegant design stands taller than most other similar bottles. The design and box simply reach out and grab the eye. Or, in the case of the bottle, it reaches *down* to grab your eye.

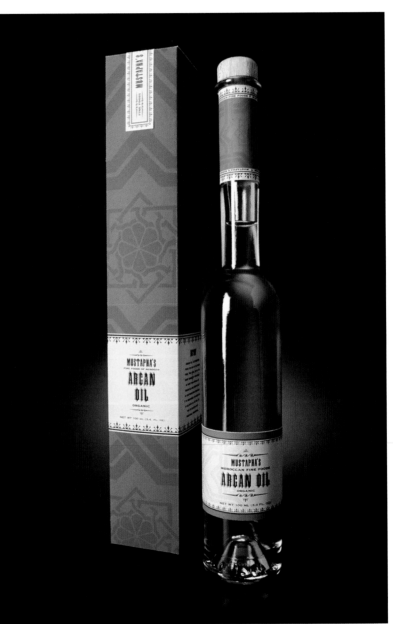

The trophy and its texture are the first things you see here. Then you look down on the lower left corner and you see that this started off as a BIG graphic. Or did it? Then you wonder: is this an example of photo manipulation with PhotoShop?

The unanswered question just adds to the appeal of this poster for Adobe.

creative firm
Sagmeister Inc.

The size, as well as the "type", grabs you. Like most Sagmeister work, there's nothing "ordinary" about this piece. It shows how great design transcends work that is merely excellent.

creative firm
Sagmeister Inc.

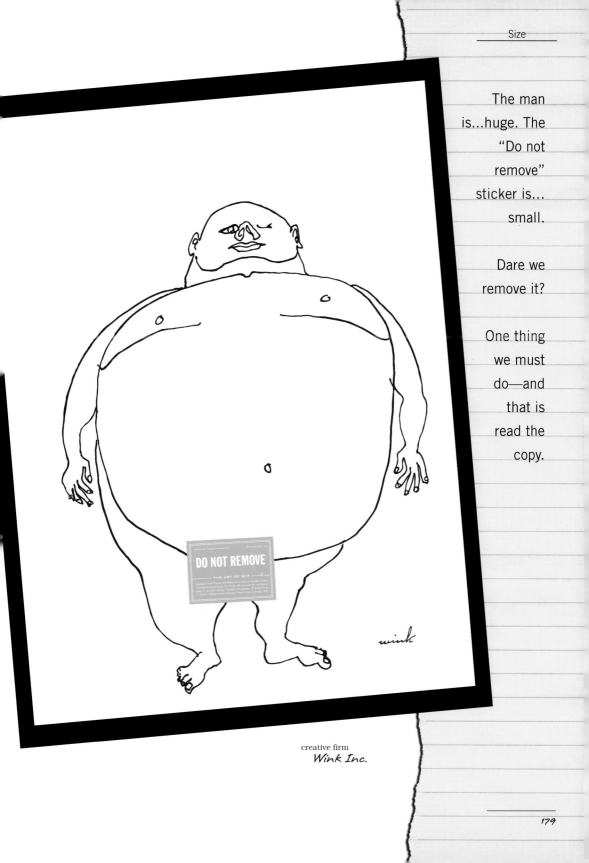

The man is...huge. The "Do not remove" sticker is... small.

Dare we remove it?

One thing we must do—and that is read the copy.

creative firm
Wink Inc.

The deep color of the bottle is standard for red wines, but the simplicity and placement of the mini-label is a touch that works well.

Understatement... is...uh...good.

Or, maybe just OK.

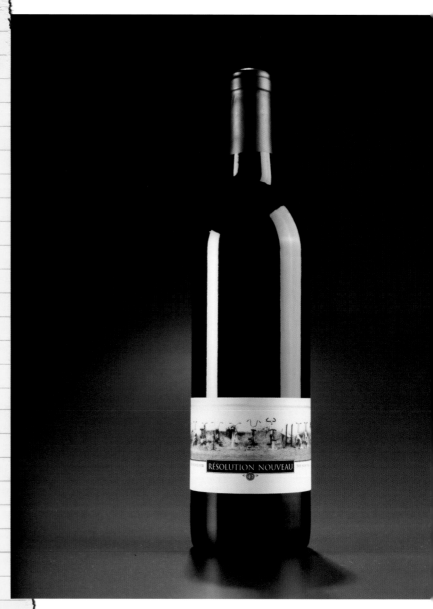

RÉSOLUTION NOUVEAU

creative firm
 TWIST inc.
designer
 Kristine Anderson Dahms
photographer
 Rick Dahms
client
 Twist & Shout,
 Vashon Island, WA

creative firm
Vaughn Wedeen
art director, designer
Rick Vaughn
client
Pecos River Learning Center

This small
booklet packs a
lot of design
punch into
minimal
dimensions.
How?
With design style.

NOT.

I repeat, NOT
for the Lily-
Livered.

The type
is huge, so there's
no missing the
message.

The boot is rela-
tively small, but
it's big enough to
help deliver the
message.

And if you don't
understand the
term "lily-livered,"
then you probably
wouldn't want to
wear the boot
anyway.

The type selection here is straight from the woodcuts that were used by Old-West era printers.

The name is perfect. "Let's meet at the old Montague place, Kemo Sabe."

MONTAGUEBOOT.COM

creative firm
Push
creative directors
John Ludwig, Chris Robb
art directors, copywriters
Ron Boucher, Gordon Weller
client
Montague Boots

This ad that
shows multiple
layers of moun-
tains shows
the beauty, and
the difficulty of
getting from
Point A to Point
B. The compari-
son of mountains
to MS is a very
understandable
way to commun-
icate the chal-
lenges the
disease presents.

the water cooler

creative firm
BBDO Atlanta
creative directors
Bill Pauls, Al Jackson,
Kyle Lewis
art director
Steve Andrews
copywriter
Carlos Ricque
photographer
Tibor Nemeth

the copier

For people with MS,
every day is a challenge.

MS NATIONAL
MULTIPLE SCLEROSIS
SOCIETY
1-800-FIGHTMS

The appealing illustration of King Kong shows that in addition to his love for Fay Wray (1933 original film), he also loves…bananas.

Oh, the delicious fruits that we have here Orange gardens miles in extent, citrons, p‹ but the most delicious thing after Phoeno

frei zitiert nach Benjamin Disraeli (1804 – 1881), Britischer Premier‹

creative firm
Scheufele

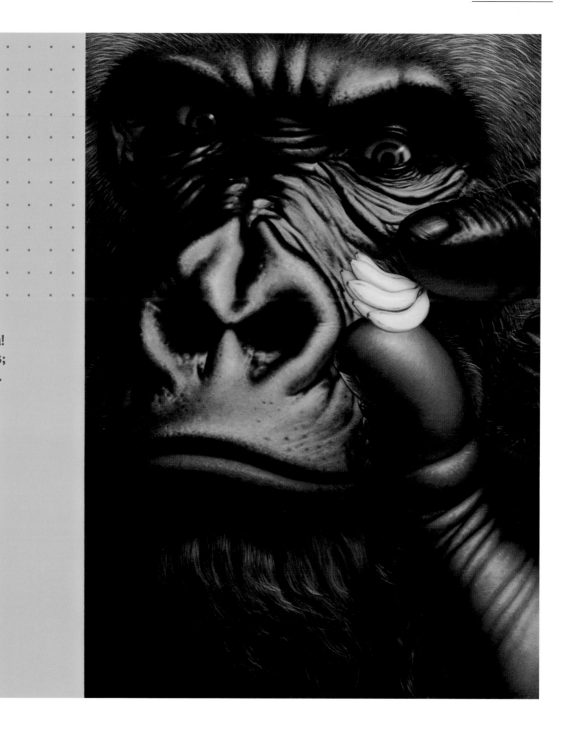

ia!
es;
a.

These highly
appealing posters
have a rustic look,
and the size of the
elements makes
you look over
every detail.

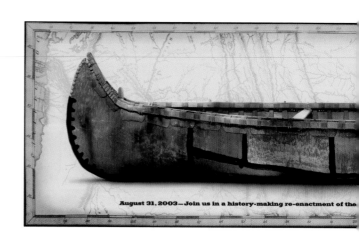

creative firm
Blattner Brunner
chief executive director
Bill Drake
creative director
Dave Vissat
copywriter
Ray Pekich
photographer
Tom Cwenar
client
Greater Pittsburgh
Convention
& Visitors Bureau

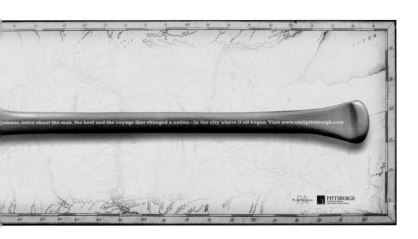

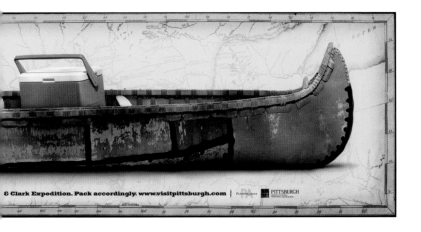

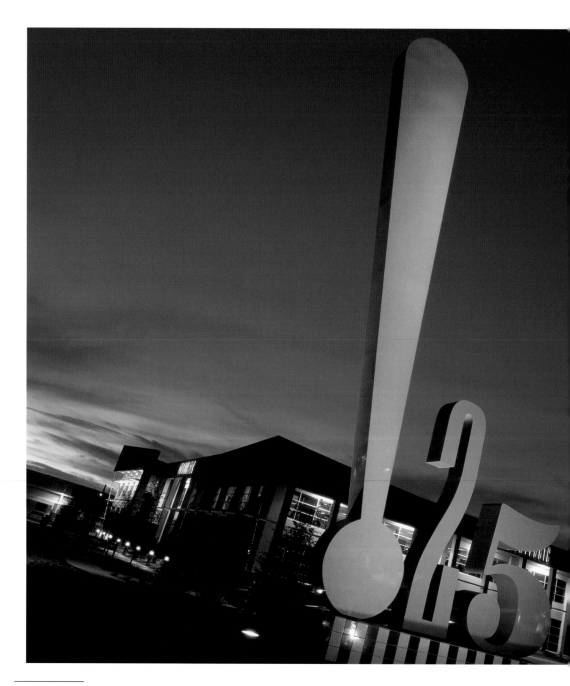

creative firm
Vaughn Wedeen
art director, designer
Rick Vaughn
client
Provident Realty

This huge sign is truly "as big as all outdoors." And there's more to it than size. The design is bright, colorful and it works.

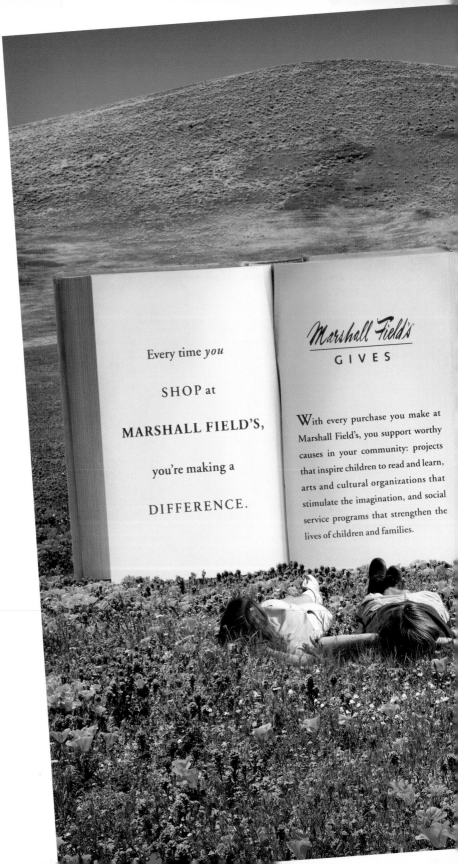

Every time *you*

SHOP at

MARSHALL FIELD'S,

you're making a

DIFFERENCE.

Marshall Field's
GIVES

With every purchase you make at Marshall Field's, you support worthy causes in your community: projects that inspire children to read and learn, arts and cultural organizations that stimulate the imagination, and social service programs that strengthen the lives of children and families.

At first you see the open book. Then you see the children lying in the field, this HUGE field, looking at the book. The actual "message" takes up only a small part of this poster. The rest is designed to draw your eye inward.

It works.

creative firm
Wink Inc.

The extreme close up on the $100 bill gives this piece a most distinctive look.

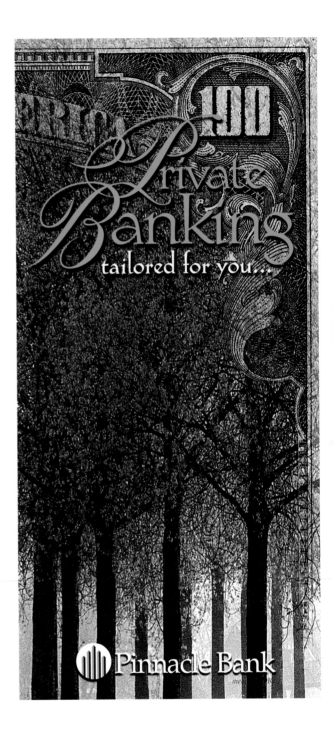

creative firm
Cocchiarella Design

This message, on the floor of Grand Central Terminal, makes a powerful statement.

The "normal" solution was to put up posters somewhere. This most creative

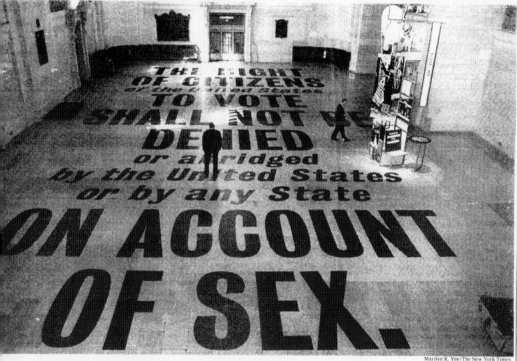

Labor Resig.

Levine to

By DAVID F

Randy L. Levine Commissioner of and one of Mayor ani's closest aides terday that he w month to become negotiator for the Major League Bas

Mr. Levine, who had been expec weeks, becomes th the Mayor's inner the private sector. made larger salari government servic eral prosecutor, M private labor lawy to work for Mr. Gi

He had done lega M. Steinbrenner 3d Yankees, where h baseball officials a

As Labor Comm tiated several key municipal labor un hallmarks of the tration's plans to local government. notable was the a municipal unions package that lower force by 17,000 with

Marilyn K. Yee/The New York Times

ght to Vote Shall Not Be Denied

ion commemorating the 75th anniversary of the 19th Amendment, at Grand Central Terminal until Oct. 6, features photographs, tracts ns of the suffrage movement. The amendment, proclaiming women's right to vote, covers the floor of the waiting room.

nning Commission Approves Limits on Sex Businesses by Slim N

creative firm
Doyle Partners
designer
Stephen Doyle
client
The New York State Division of Women

solution was to use the huge amount of space available. Brilliant.

Lucky Jim. His troubles end...No. "Our" troubles end tonight. This package contains...well, you must open it to find out. And only the strong willed will resist.

creative firm
Red Design

creative firm
DJG Design
designer
Danny J. Gibson

The background colors are eye-catching, but it's really the finger (or missing finger) that gets the attention.

Then, you see the title and you get an idea of what happened to the finger.

Reader involvement is high in this piece. When you can make the reader look a second time, you have a powerful piece of communication.

Fire prevention posters usually are ho-hum pieces, nothing new. But these posters…they knock you off your feet with burned images that show the result of forest fires. Compelling and attention getting.

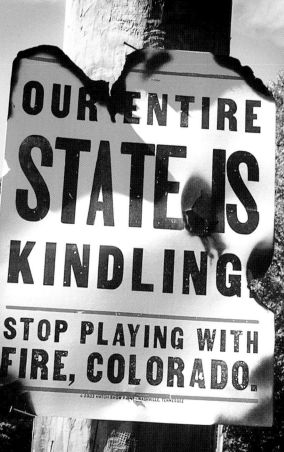

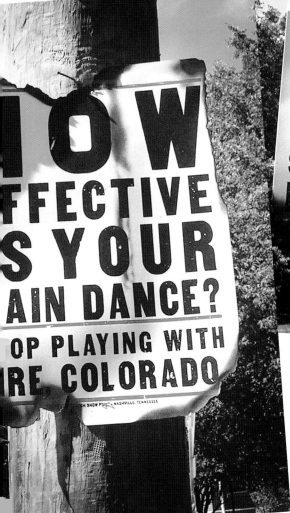

creative firm
Cultivator Advertising&Design
creative directors
Tim Abare, Chris Beatty
designers
Chris Beatty, August Sandberg
copywriter
Tim Abare
client
Colorado Wildlands

So what is this, anyway? An ad for a water heater?

Wait. It has a picture at the bottom and something about a concert.

Surprise. This poster grabs the attention by standing out from the pack in a most creative way.

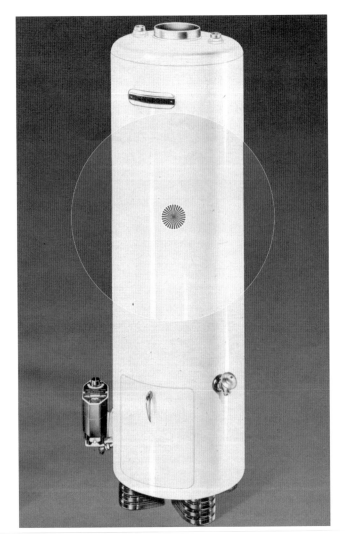

Modest Mouse...................$20
with Special Guest
April 11th, 2004 at the
Paramount Theatre in Seattle
a House of Blues concert
www.Ticketmaster.com

creative firm
Modern Dog
art director, designer, illustrator
Michael Strassberger
client
House of Blues

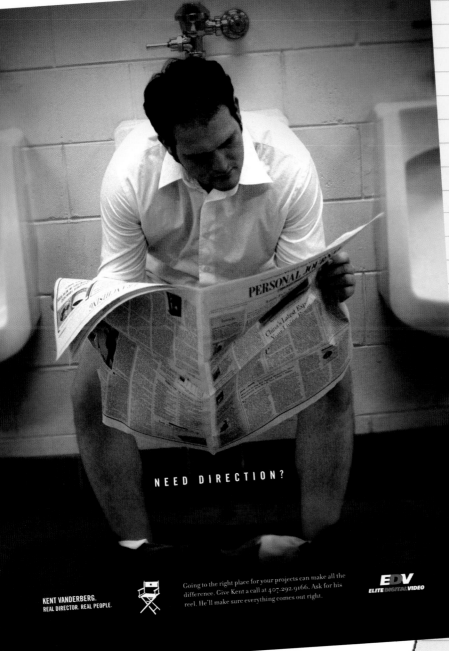

NEED DIRECTION?

KENT VANDERBERG.
REAL DIRECTOR. REAL PEOPLE.

Going to the right place for your projects can make all the difference. Give Kent a call at 407.292.9166. Ask for his reel. He'll make sure everything comes out right.

EDV
ELITE DIGITAL VIDEO

The first emotion when you see this is total surprise at seeing a guy sitting on the john reading a paper. In a magazine ad, of all places.

Then, you realize that he's not on the john at all. He's sitting on a <u>urinal</u>.

He is in need of direction. And that's the point, told in a very memorable way.

creative firm
Push
creative directors
John Ludwig, Chris Robb
art directors, copywriters
Mark Unger, Gordon Weller
client
Kent Vandenberg/Director

You're driving down the highway, and you find that the billboard about preventing forest fires... has burned down. Almost completely. Simply, a stroke of genius.

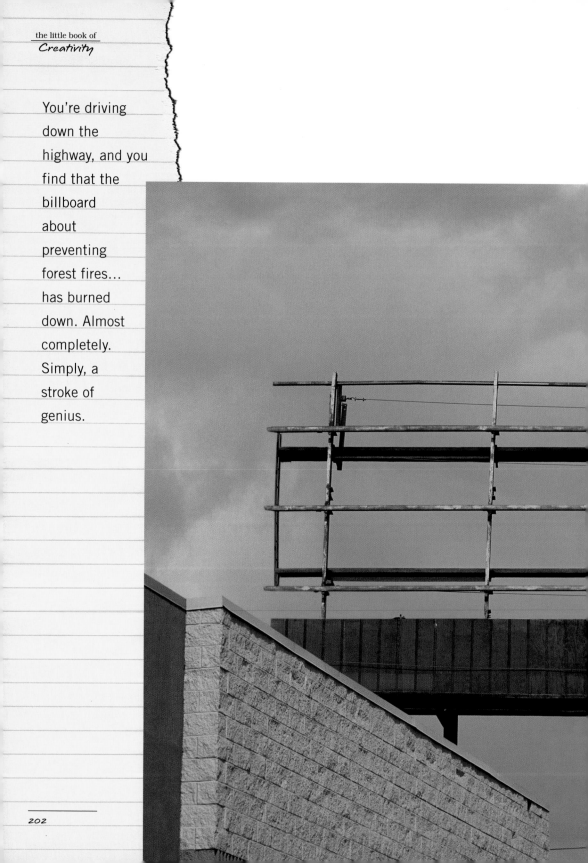

creative firm
Cultivator Advertising&Design
creative directors
Tim Abare, Chris Beatty

designers
Chris Beatty, August Sandberg
copywriter
Tim Abare
client
Colorado Wildlands

How do you create a long-copy ad that will be read?

How about doing an "obituary" page for lawn and pest creatures?

This ad breaks all the conventions of pest control advertising and makes for a very compelling ad.

The message is very simple: have bugs that you want dead? Call Middleton.

Vero Beach Lawn & Pest Obituaries

IN LOVING MEMORY
PETER DOLLARWEEDER

Peter Dollarweeder, 2 days, passed away Saturday, May 10, 2003. Mr. Dollarweeder's favorite pastime was weaving his way through moist grass, sneaking nutrients away from the surrounding lawn, while putting a stranglehold on the root system. Services will take place in the ditch behind the house at 5601 Lemongrass Way at 11 a.m. on Tuesday, May 13, 2003. Cremation arrangements by The Bonfire in the Garbage Can Crematory.

IN LOVING MEMORY
ROBERT THOMAS ANTSWORTH "BOB"

Robert Thomas Antsworth, "Bob" died Saturday, May 10, 2003 at his home in the playground sandbox located at 22 Cypress Drive. Mr. Antsworth played an integral part in the takeover of the playground sandbox from the human family known as "The Johnsons" in the spring of 2002. His efforts to secure the Northwest corner of the area were, to quote his commanding officer, Cmdr. John T. Blightyeranrkles, "the stuff heroes are made of." He was preceded in death by his mother and father. Services will be held at 11 a.m. on Tuesday, May 13, 2003 along the crack in the sidewalk near the garage.

IN LOVING MEMORY
STANLEY ROACHFELTER

Stanley Roachfelter of 459 Twelve Oaks Boulevard, Apt. 39B passed away Saturday, May 10, 2003 at the age of fourteen months. Hatched in the cupboards beneath the kitchen sink, Mr. Roachfelter moved from room to room until finally relocating back to the kitchen and establishing the colony underneath the refrigerator. "Roachfelters", as it came to be known, quickly established itself as "the" hot spot for the finest in crumb cuisine at 459 Twelve Oaks Boulevard. Upon deciding to expand operations, Mr. Roachfelter began exploring new locations for a second eatery, only to meet his match while coming face-to-face with an employee from Middleton Lawn & Pest Control. For the time being, he is survived by his wife, Missy and their numerous offspring who have temporarily relocated to 459 Twelve Oaks Boulevard, Apt 39A. Services are scheduled for Wednesday, May 14, 2003 at 6 p.m. Funeral arrangements by The Hole-In-The-Wall Funeral Home and Cemetery.

IN LOVING MEMORY
THEODORE McCRICKET

Theodore McCricket, 1 year, passed away Saturday, May 10, 2003. Throughout his life Mr. McCricket enjoyed destroying the root systems of most grasses, but his personal favorites were always Bermuda and Bahia. Services will be held at 1 p.m. on Wednesday, May 14, 2003.

IN LOVING MEMORY
BERNICE CRAB GRASSOVICH

Bernice Crab Grassovich, "Crabbie", 3 years, died Saturday, May 10, 2003. Never a fan of the cold weather, Ms. Grassovich was always at her best when it was hot and humid outside. It was during the summer months that she and her friends would often take trips to all parts of the lawn, creeping along and making sure to deposit enough seeds in the most desirable locations, so they could come back the following year. Until a recent visit from Middleton Lawn & Pest Control, Ms. Grassovich and her closest friend, Regina Chickweedski, shared a piece of land toward the back of the property located at 12903 First Ave. Ms. Grassovich is survived by her two-hundred and ninety-three seedlings who currently occupy the lawns of neighboring properties untreated by Middleton. Services will be held at 10 a.m. on Saturday, May 17, 2003 in the beige plastic garbage can with the blue lid. Burial arrangements by The Local Landfill.

IN LOVING MEMORY
THE MOSQUITOSANO FAMILY

The Mosquitosano Family of 2121 Hummingbird Lane. The entire Mosquitosano family met its demise Saturday, May 10, 2003 after apparently attempting to take up residence in the shrubbery on the side of the house. Neighbors report earlier in the week that an employee from Middleton Pest Control had been seen in the area. Visitation for friends will be held from 10 a.m. - 1 p.m. on Friday, May 16, 2003 with funeral services following later in the day near the koi pond out back.

IN LOVING MEMORY
BARRY L. PANTRYPEST

Barry L. Pantrypest, 11 days, of 1585 Lakeview Lane died Saturday, May 10, 2003. Arriving at Lakeview Lane in a box of wagon wheel pasta, Mr. Pantrypest and his wife, Sue Ellen, quickly started a family on the bottom shelf of the pantry. His favorite activities were crawling, jumping, climbing, flying, taking long strolls along the kitchen counter and spending time with the family. Mr. Pantrypest was a connoisseur of all grains, having sampled many from around the entire kitchen, but his personal preference was always the open bag of white rice located on the pantry's second shelf. A Memorial service will be held on Monday, May 12, 2003 underneath the dishwasher at 11 a.m.

IN LOVING MEMORY
GEN. MICHAEL T. WORMER

Gen. Michael T. Wormer of 52 Willowbend Circle passed away on Saturday, May 10, 2003 at the age of 4 weeks. At an early age, Gen. Wormer was a dedicated Armyworm, causing a considerable amount of damage to the entire property's plot of St. Augustine grass. A potential star in the making, he quickly worked his way up through the ranks, becoming one of the youngest Generals to ever lead an attack on grass treated by Middleton Lawn & Pest Control. Sadly enough, this is where he would meet his demise. In his final speech before crawling off to battle, Gen. Wormer guaranteed victory and boldly declared that life would be different for all Armyworms upon his return. Gen. Armyworm's remains were unfortunately devoured by the Blue Jay family of 54 Willowbend Circle before a recovery mission could be organized, therefore a celebration of his life will take place on Friday, May 16, 2003 at 10:30 a.m. in the backyard.

IN LOVING MEMORY
EDWARD J. TERMITOPOLOUS

Edward J. Termitopolous, 1 year, passed away Saturday, May 10, 2003. A devoted worker, Mr. Termitopolous developed a taste for floor joists at an early age. He went on to join the colony at 335 Mockingbird Lane, quickly rising up through the ranks. Then in January of 2003, after months of research, Mr. Termitopolous successfully discovered the way to get past nearly every Termite Bait system, now known around most termite circles as "The Eddie Method". Mr. Termitopolous was currently working on trying to get past the Termidor system offered by Middleton Pest Control when he unknowingly transferred it to everyone in his colony. As a result, the fate of his nearly three million relatives is also in jeopardy at this time. Services will be held in the elm tree in the front yard at 12 p.m. on Tuesday, May 13, 2003.

IN LOVING MEMORY
ELLA NUTT SEDGEWICK

Ella Nutt Sedgewick, "Yella Ella" officially passed away Saturday, May 10, 2003 at her home in the backyard of 2553 Jasper Way. Her exact birthdate unknown, Ms. Sedgewick first appeared in the lawn sometime in the summer of 2000. From the beginning she was a fierce competitor with the surrounding sod. In her first year, she won many competitions for space, water, nutrients and light and was extremely good at invading thinning, unhealthy turf. During her second year, after the homeowners laid down some slow bought herbicide, it was feared that "Yella Ella" was gone for good, but she came back with a vengeance in 2002 and single-handedly overtook the entire backyard. What initially looked to be another strong year for Ella now looks to be a sad ending to a brilliant career. Memorial services will be held on Thursday, May 15, 2003 at 10 a.m. underneath the hibachi on the patio.

IN LOVING MEMORY
JOHNATHAN ROACHMAN "ROACHY"

Johnathan Roachman, "Roachy" died Saturday, May 10, 2003, at the age of eight months, fifteen days. A devoted husband and father, Mr. Roachman enjoyed nothing more than sitting around with his wife, eighty-one daughters, seventy-three sons and hundreds of grandchildren to feast upon his favorite dinner: the glue on the back of postage stamps and envelopes. He later went on to climb professionally, but was forced to retire after a near miss from a flying shoe resulted in a broken antennae. A celebration of his life will take place at 2 p.m. on Wednesday, May 14, 2003, in the manila envelope behind the filing cabinet in the garage, with burial services scheduled for later that evening at 5 p.m.

IN LOVING MEMORY
DIETER ROACHBERGER

Dieter Roachberger, 1 year, passed away Saturday, May 10, 2003. Coming to the United States a few months ago on a shipping crate from his homeland of Germany, Mr. Roachberger was able to make a good life for himself. Arriving with only the cardboard box he was born in, he soon made himself at home in the kitchen pantry at 10027 Berkeley St. A good husband and family bug, he was father to forty-five sons and thirty-two daughters. A devoted member of the Late Night Crumb Finders Brigade, he was able to survive many a close call from the dreaded Fuzzy Slipper. The family requests that in lieu of flowers, donations may be made to the American Rolled-Up Newspaper Society. Memorial services are scheduled for Tuesday, May 13, 2003 at 4 a.m. Funeral arrangements by The Hole-In-The-Wall Funeral Home and Cemetery.

IN LOVING MEMORY
I. EDITH WOOD

I. Edith Wood, eighteen months, passed away Saturday, May 10, 2003. Born in the floorboards at 235 Briarwood Ave. her family moved to the attic area in late 2002. Ms. Wood gave birth to over nine thousand children of which she is survived by eight-thousand eight-hundred and twenty-two of them who have since relocated. Services will be held at 11a.m. on Tuesday, May 13, 2003, under the sink.

IN LOVING MEMORY
SANDY FLEA

Sandy Flea, 5 months, passed away Saturday, May 10, 2003. An avid lover of all animals and traveling, Ms. Flea thoroughly enjoyed spending her time moving from one house to the next on the back of a passing mongrel. Memorial services are scheduled to begin at 10 a.m. Friday, May 16, 2003 on the back of the Golden Retriever named "Skippy".

IN LOVING MEMORY
WILLIAM J. CHINCHMAN "BILL"

William J. Chinchman, "Bill", 3 weeks, of 14452 Elm St. passed away on Saturday, May 10, 2003. He is survived by his mother, father, five brothers and six sisters. An avid sucker of plant juices, Mr. Chinchman delighted in removing every single drop of liquid nutrient from his favorite grass, St. Augustine. In fact, if a new patch of St. Augustine grass was about to be replaced somewhere on the lawn, you could be sure that He was personally responsible for the big brown, dried-out patch of grass in the middle of the front yard. Donations may be made in his name to the 14452 Elm St. Resodding Fund. Burial services will take place at 6 p.m. on Wednesday, May 14, 2003 underneath the dried-out patch in the front yard.

creative firm
Push
art directors, copywriters, creative directors
Gordon Weller,
Ron Boucher,
John Ludwig
client
Middleton Lawn & Pest Control

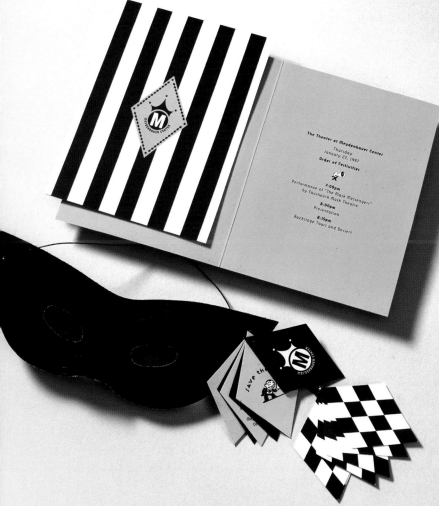

The masked ball invitation comes with a... mask. (To quote Jack Nickolson: "I'm going to make this as easy for you as I can...")

The mask does just that.

creative firm
TWIST inc.
designer
Kristine Anderson Dahms
photographer
Rick Dahms
client
Meydenbauer Center,
Bellevue, WA

At first glance,
this piece looks
like an idyllic
walk in the
forest, with
babies and
puppies playing
(or are they baby
wolves?).

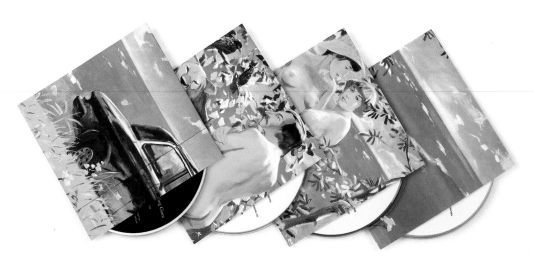

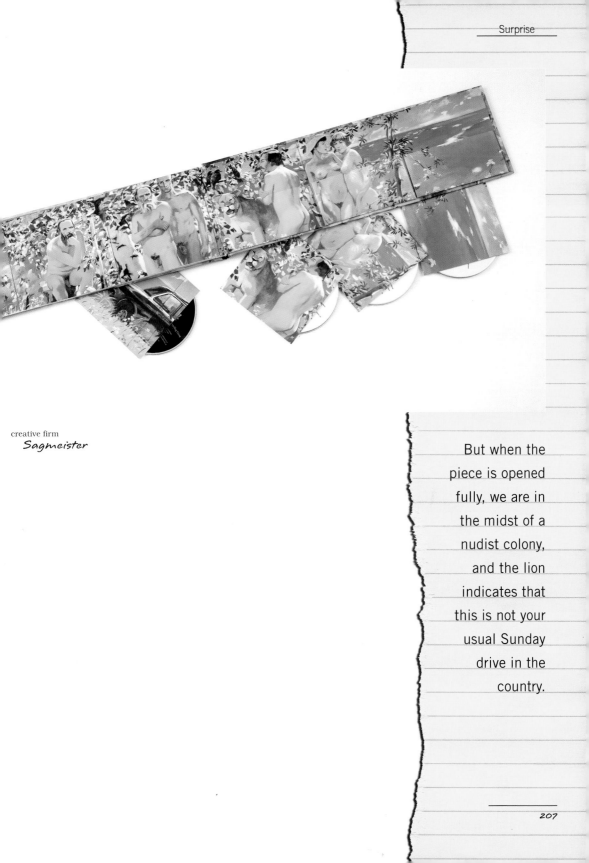

creative firm
Sagmeister

But when the piece is opened fully, we are in the midst of a nudist colony, and the lion indicates that this is not your usual Sunday drive in the country.

The use of a game
with a spinner
is...phenomenal.

creative firm
TWIST inc.
designer
Kristine Anderson Dahms
photographer
Rick Dahms
client
Phenomena! Special Events

creative firm
Push
creative directors, art directors, copywriters
John Ludwig,
Ron Boucher
client
Living Quarters

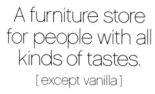

A furniture store
for people with all
kinds of tastes.
[except vanilla]

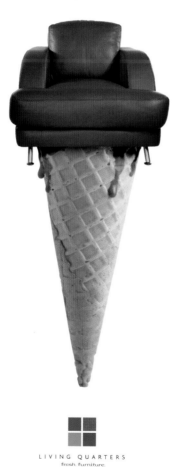

LIVING QUARTERS
fresh. furniture.

Waterford Lakes Town Center • Herndon Village Shoppes
www.living-quarters.com

The first thing you
see here is a nice
ice cream cone.

And atop the cone is
most everyone's
favorite—chocolate.

Chocolate colored
leather. And a very
classy looking
modern chair.

The headline adds
flavor to the ad,
with "all kind of
tastes (except
vanilla) as a great
copy line.

Sweet.

O.K., imagine a
nude shower scene
for a film festival.
Think **Janet Leigh**
from Psycho. Or
maybe, what's her
name—Lovelace?
From that movie...
No. Think a
chubby, hairy-
chested guy who is
proudly displaying
his gold pass to
the Florida Film
Festival.

creative firm
Lure Design
designer
Jeff Matz

photographer
Doug Scaletta
copywriter
Jane Harrison

client
Florida Film Festival

creative firm
Sandstrom Design
creative director, art director
 Steve Sandstrom
designers
 Shanin Andrew (for Grocery RTD),
 Andrew Randall (for Infuser Tin)
production manager
 Kirsten Cassidy
client
 Tazo

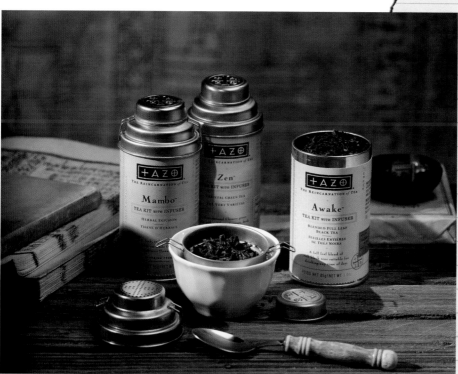

You just know that buying the "tea kit with infuser" will provide you with a product that will be very tasty.

The texture of this packaging, the metal top with its very functional, very inviting appearance, makes it say "buy me" as it sits on the shelf. The unusual colors of the paper portion of the package are similarly inviting.

This isn't your usual business card. First of all, it is made of metal. Then, there is a Braille embossing at the top, along with the KEA name. Finally, paper with each employee's personal details such as phone, fax, etc., is attached to the metal.

This is one card that won't easily get lost. And it will certainly be well remembered. And that's a major function of business cards.

creative firm
Templin Brink Design
creative director, designer
Joel Templin
client
KEA

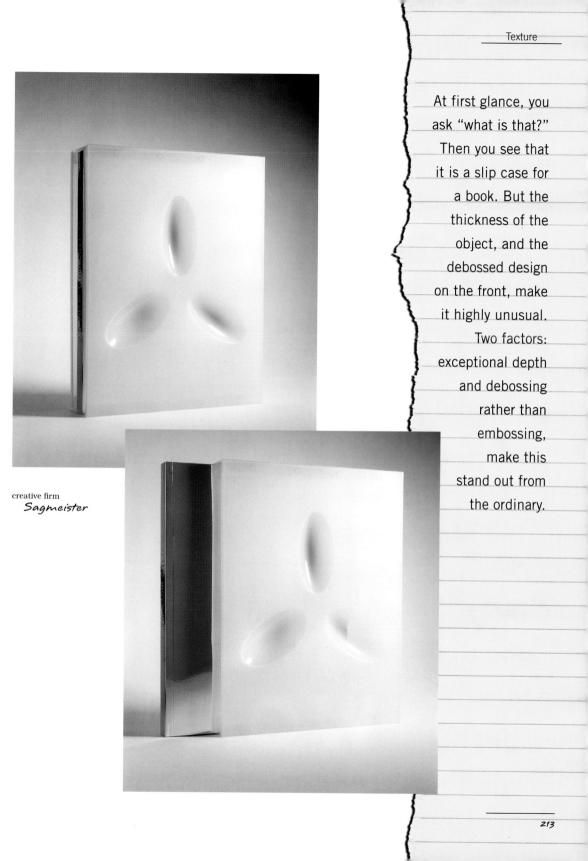

creative firm
Sagmeister

At first glance, you ask "what is that?" Then you see that it is a slip case for a book. But the thickness of the object, and the debossed design on the front, make it highly unusual. Two factors: exceptional depth and debossing rather than embossing, make this stand out from the ordinary.

I know this is a logo, printed on flat pages, so there is no texture here. But the implied texture of the giant red-wood tree is the highlight of this piece. Being able to visually communicate touch and feel on paper is a major creative skill.

creative firm
Michael Schwab Studios
creative director
Rich Silverstein
art director
Jami Spittler
client
Golden Gate National Parks Association

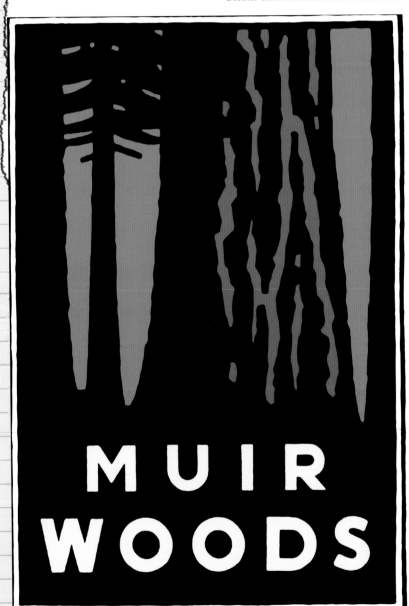

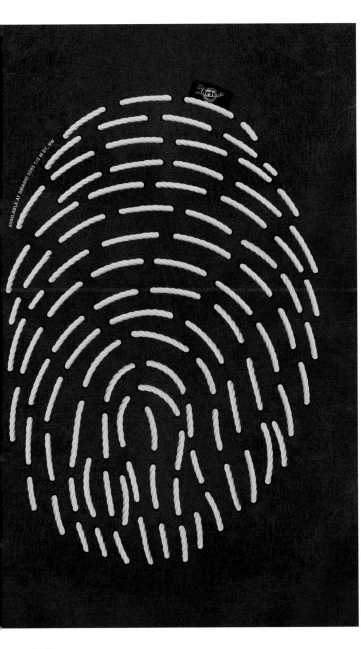

The texture in this ad for shoes literally shouts "look at me."

The use of a thumb-print shape conveys the idea of individuality, and the simple message of "where to buy" is confined to a single line of type at the tip of the textural image.

It's very memorable, and that's what creativity is all about.

creative firm
Arnika
art director
Diana Tung
copywriter
Claire Tiffey
client
Smash!

This invitation to a celebration of natural medicine includes simulated grass growing, which is a strong attention getter.

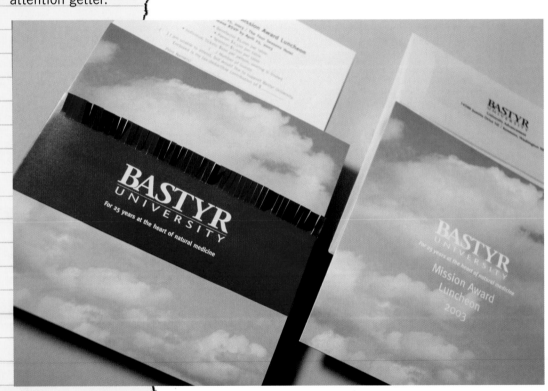

Compare this to the standard "invitation," and you see just how good this actually is.

creative firm
 TWIST inc.
designer
 Kristine Anderson Dahms
photographer
 Rick Dahms
copywriter
 Laurie Taylor
client
 Bastyr Natural Health
 University, Seattle

When McGaughy
Design was reno-
vating, they had
temporary
stationary made.
The look:
something very
transient and
temporary.

creative firm
McGaughy Design
art director, designer
Malcolm McGaughy

PARDON OUR DUST
MCGAUGHY DESIGN
IS UNDERGOING RENOVATION

WE CAN BE REACHED AT:
5356 SEQUOIA FARMS DRIVE
CENTREVILLE, VA 20120
703·830·8024 / FAX 830·3019
MCGDESIGN@AOL.COM

Idea written on a napkin. We've all done it.

The napkin texture gives this "rough sketch" poster an added dimension.

creative firm
DJG Design
designer, copywriter
Danny J. Gibson
client
James Hoskins

creative firm
 TWIST inc.
designer
 Kristine Anderson Dahms
photographer
 Rick Dahms
client
 Essential Baking Company
 Seattle, WA

Here, the texture is the product, which is allowed to show through the openings on the boxes. To make this a more compelling design, the colors used are softened, giving the products even more visual taste appeal.

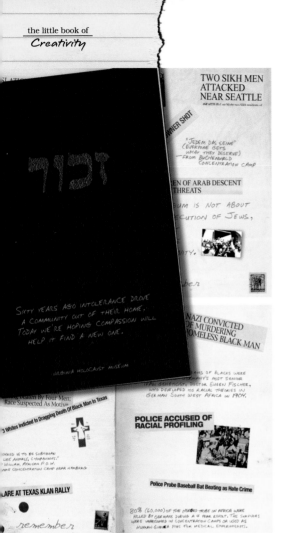

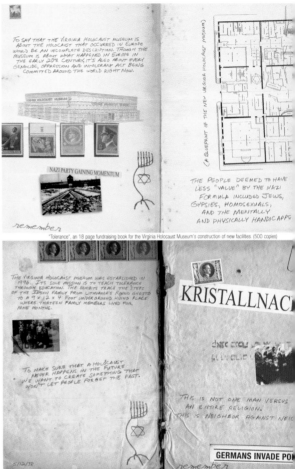

"Tolerance", an 18 page fundraising book for the Virginia Holocaust Museum's construction of new facilities. (500 copies)

When you see this direct mail piece, it's like you are seeing an actual book, and the topic makes it seem that much more real.

creative firm
Arnika
art director
 Michael Ashley
copywriter
 Dinesh Kapoor,
 Michael Ashley,
 Matt Blum
client
 VA Holocaust Museum

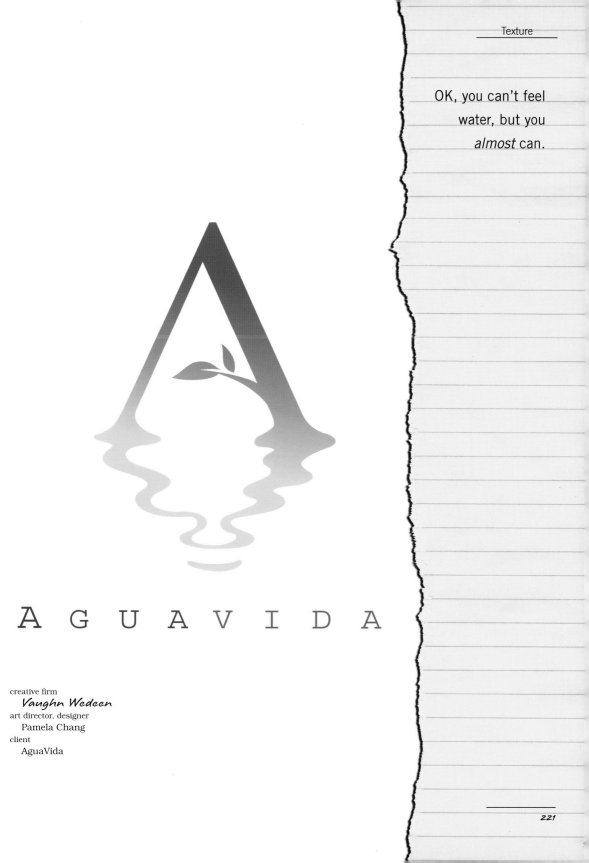

OK, you can't feel
water, but you
almost can.

AGUAVIDA

creative firm
Vaughn Wedeen
art director, designer
Pamela Chang
client
AguaVida

The dominant element for this poster is the texture of a dress, worn by "Cutie" the title role in "Death Cab for Cutie". What does the red dress symbolize? Does Cutie actually die? Come to the theater and see.

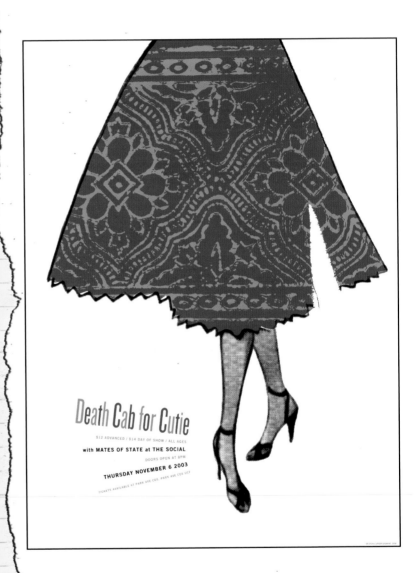

Death Cab for Cutie

$12 ADVANCED / $14 DAY OF SHOW / ALL AGES
with **MATES OF STATE at THE SOCIAL**
DOORS OPEN AT 8PM
THURSDAY NOVEMBER 6 2003
TICKETS AVAILABLE AT PARK AVE CDS. PARK AVE CDS UCF

creative firm
Lure Design
designers
Jeff Matz, Kim Fox
client
Foundation

creative firm
DJG Design
designer, copywriter
Danny J. Gibson
client
Nathan Reusch

The texture in this piece is a visual variety of notebook paper, with the addition of water-blurred areas that give it added appeal.

The colors in the sketches, as well as the primitive style, make this a very creative piece.

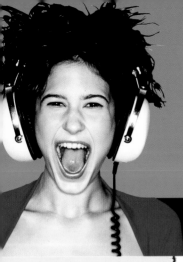

Wired Thing, You Make My Heart Sing.

TV. Web. Phone.

Three products. One company. Hit it.

1-877-824-2288

AT&T | **BROADBAND**

These billboards for ATT Broadband have BIG faces. Attention-getting faces, and bold colors for the background. And copy that is snappy.

creative firm
Vaughn Wedeen
art director, designer
Steve Wedeen
client
ATT Broadband

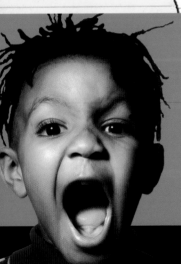

Born to be Wired.

TV. Web. Phone.

Three products. One company. Turn it loose.

1-877-824-2288

AT&T | **BROADBAND**

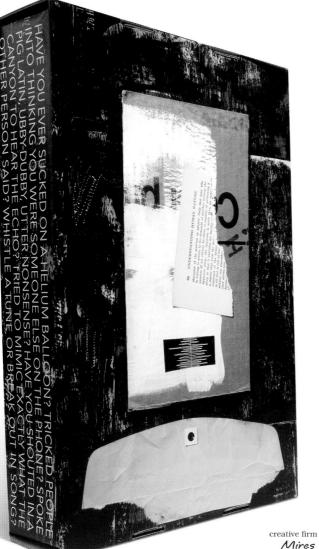

HAVE YOU EVER SUCKED ON A HELIUM BALLOON? TRICKED PEOPLE INTO THINKING YOU WERE SOMEONE ELSE ON THE PHONE? SPOKE PIG LATIN, UBBY-DUBBY, UTTER NONSENSE? HAVE YOU SHOUTED IN A CANYON TO HEAR THE ECHO? TRIED TO MIMIC EXACTLY WHAT THE OTHER PERSON SAID? WHISTLE A TUNE, OR BREAK OUT IN SONG?

You can almost feel the different textures on this printed piece. Using multiple pieces of paper "pasted" onto the box gives it an appeal that says "pick me up."

creative firm
Mires
creative director
Scott Mires
designer
Jen Cadam
illustrator
Gerald Bustamante
copywriter
Eric LaBrecque
client
Woods Lithographics

This
poster
shows a
poster
taped to
a wall.
Yet, the
drawing
extends
beyond
the
"poster,"
as does
the type.

By
breaking
down the expected
lines that define
poster and wall, this
poster becomes very
interesting, and is a
real attention
grabber.

april 7th
10pm

the
bottleneck
737 new hampshire
lawrence, kansas

the delgados aerogramme
namelessnumberheadman

creative firm
DJG Design
designer, copywriter
Danny J. Gibson
client
Jason Lewis

One of the interesting ramifications of the graphics revolution is that "type" has no boundaries, no walls. This is an all-type illustration, yet the visual message is powerful and unmistakable.

Hernando de Soto *is author of "The Mystery of Capital" and founder of the Institute for Liberty and Democracy in Lima, Peru.*

enced mainly economic suffering, tumbling incomes and high anxiety. Those who favor the market had forgotten that the only way capitalism

ment in the 1990's by reforming laws to make it easier for the poor to gain legal title to their homes and small businesses. In my experience, the

Any campaign that does not drive a political and economic wedge between terrorists and the poor is likely to be short-lived.

Stephen Doyle

Condemnation Without Absolutes

By Stanley Fish

CHICAGO

During the interval between the terrorist attacks and the United States response, a reporter called to ask me if the events of Sept. 11 meant the end of postmodernist relativism. It seemed bizarre that events so serious would be linked causally with a rarefied form of academic relativism.

the particular lived values that unite us and inform the institutions we cherish and wish to defend.

At times like these, the nation rightly falls back on the record of aspiration and accomplishment that makes up our collective understanding of what we live for. That understanding is sufficient, and far from undermining its sufficiency, postmodern thought tells us that we have grounds enough for action and justified condemnation in the democratic ideals we embrace, without grasping

better position to respond to it by taking its true measure. Making the enemy smaller than he is blinds us to the danger he presents and gives him the advantage that comes along with having been underestimated.

That is why what Edward Said has called "false universals" should be rejected: they stand in the way of useful thinking. How many times have we heard these new mantras: "We have seen the face of evil"; "these are irrational madmen"; "we are at war against international

Vladimir Putin of Russia insisted that any war against international terrorism must have as one of its objectives victory against the rebels in Chechnya.

When Reuters decided to be careful about using the word "terrorism" because, according to its news director, one man's terrorist is another man's freedom fighter, Martin Kaplan, associate dean of the Annenberg School for Communication at the University of Southern California, castigated what he saw as one more in-

(right column, partially visible)

and Bush since 1989 addition covert action in Afghanist were those antiterrorist mi ried out?

3. How many U.S., Britis sibly French commandos noitering in Afghanistan have they made contact Qaeda Afghans or Talib tents willing to be bribed hideouts? Are commando making deals with local wa them to be part of post-Tal

4. Has our bombing knoc Taliban broadcasting facil the Voice of America taker broadcast Muslim clergy c as blasphemous the suicid ers' path to paradise? A Czechs trying to run Radio rope out of Prague?

5. What vital informatio held back from the F.B.I. by our Arab coalition "p Did the U.S. share intellig Saudi, Egyptian and Jord masters that compromise Western sources in the Ara

6. Has Prime Minister secretly told President Bu absent absolute proof of Sa sein's participation in the attack — he should count f of any move on nuclear weapons being produced in planning for "Phase II" moval of Saddam — been Pentagon?

7. What rule of engage been given our special forc ing Osama bin Laden an aides — to kill or to captu potential benefits to us of tion outweigh the benefit to trial's world forum and s slaughter of hostages?

8. What anti-terrorist hel Saudis, Egyptians and warned us not to ask their what arguments are going the Bush administration a we have so far supinely a their demands?

9. What, if any, is the role Baker, Brent Scowcroft an Djerijian in trying to pers to appease "the Arab stree suring Israel to give up its c terrorism? Will bin Laden televised embrace of the P. panic the coalitionary Wh into giving Hamas a terror that would further radicaliz around the world?

10. What secret negotiz underway with Russia to p escape of Al Qaeda leav Chechnya? We want to sto wouldn't bin Laden's pres Vladimir Putin an excuse ate all separatists there?

11. Since the two major

creative firm
Doyle Partners
designer, photographer
Stephen Doyle
client
The New York Times

The typography on this poster is unusual, but then so is the use of color. And the die-cut adds to its appeal. Add all of these elements together, and you get a piece that attracts attention.

creative firm
DJG Design
designer, copywriter
Danny J. Gibson

The powerful use of "sticks" for type make this cover jump off the page and grab your mind. Creativity is often the result of thinking "what else could I do that's not ordinary?" This is an extraordinary solution to a common project: design a book jacket.

creative firm
Doyle Partners
designer
Stephen Doyle
client
Knopf

The typography here is straight from the old box in the corner—the one with the wooden type that you bought at the flea market. Well, wooden type is not very usable—unless you want to do something just like *this*.

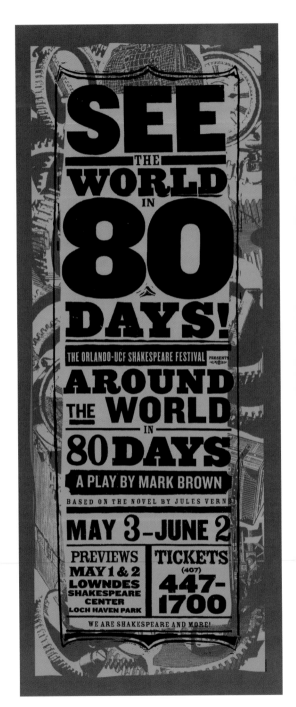

creative firm
Lure Design

Cause an effect.

creative firm
Doyle Partners
designer, photographer
Stephen Doyle
client
AIGA

The simple message here: voting causes ripples. Clever idea, excellent execution. What more can you ask for?

You can't tell a book by its cover, but covers DO grab attention. Or not. This jacket features one of the best-known writers in the world, so his name is the dominant sales pitch. By using an effect with letters and pins and the resulting "shadow," the author's name appears on the cover *twice*. Very clever.

THE STORIES OF

VLADIMIR

VLADIMIR

NABOKOV

NABOKOV

creative firm
Doyle Partners
designer
Stephen Doyle
photographer
Geoff Spear
client
Knopf

A new album poster. Ho-hum. In the hands of ordinary creative people, an ordinary solution would result. In the hands of top creative people, magic emerges. The eyes grab you, the copy holds you.

creative firm
Sagmeister Inc.

This poster for a
Sagmeister exhibit
at a museum
in Zurich
places some of
his work on
the clothing of
the men in
the photo.
Their similar
looks almost
asks the
question: will
the real
Stefan
Sagmesiter
please
stand?

creative firm
Sagmeister Inc.

Thursday, Aprixxil
Twenty - xxxx -
Fourth

@@ Y.J.'s SnaCK BAR

xxx/:00 pm / no cover

DJGDESIGN.COM

Thursday, Aprixxil
Twenty - xxxx -
Fourth

@@ Y.J.'s SnaCK BAR

xxx/:00 pm / no cover

The "type" for this poster is anything but type.

The very creative hand lettering makes this hard to read, but also makes it something you MUST read.

creative firm
DJG Design
designer, writer
Danny J. Gibson
client
Thom Hoskins and Nathan Reusch
Thom Hoskins & Mail Order Midgets

Banners are often
"ho-hum" pieces
that get more yawns
than attention.

This one simply
commands attention,
quietly, yet
effectively. The
typographic use of
black and grey to
separate the two
messages works well,
yet keeps the dignity
that the project
requires.

creative firm
 Doyle Partners
creative director
 Stephen Doyle
designers
 Stephen Doyle, Andrew Gray
client
 National Design Museum

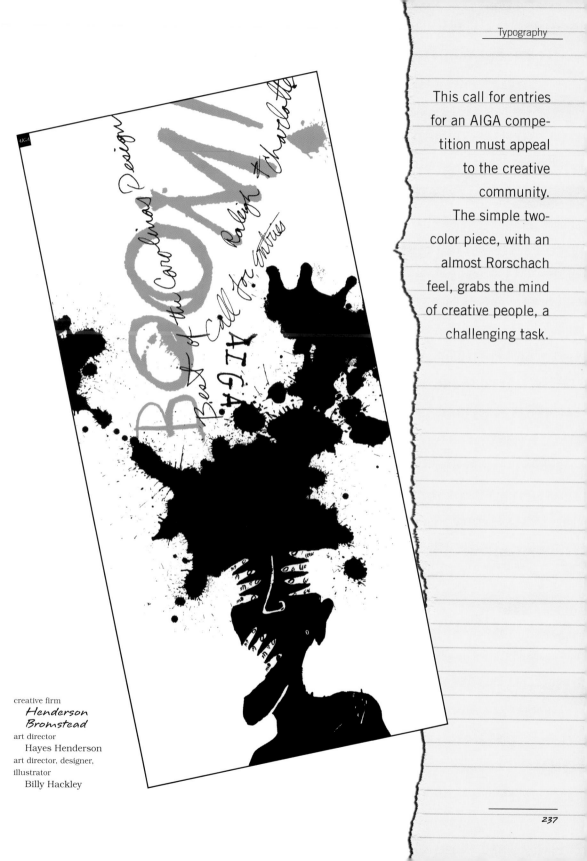

This call for entries for an AIGA competition must appeal to the creative community. The simple two-color piece, with an almost Rorschach feel, grabs the mind of creative people, a challenging task.

creative firm
Henderson Bromstead
art director
Hayes Henderson
art director, designer, illustrator
Billy Hackley

The title "2001 An Arts Odyssey" is a nice takeoff on the Stanley Kubrick film. There are the logos, hand drawn cover, and all the destinations of the event. It's just as if a tourist had done the design on the cover while enjoying the experience.

"Sharing the experience" is a nice creative tactic. This is a good example of how to execute it.

creative firm
Wink Inc.

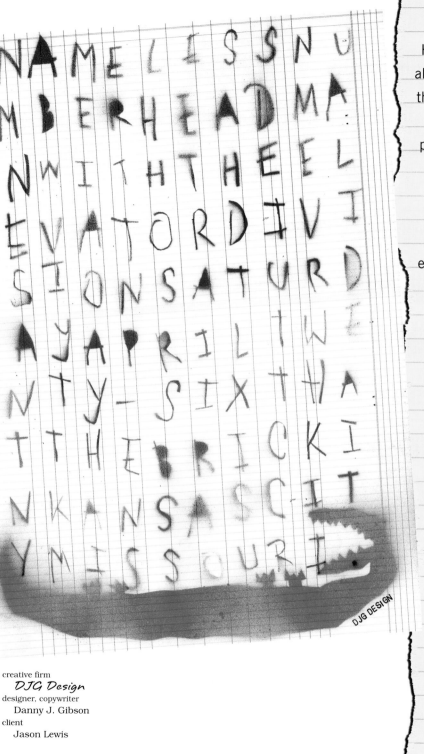

Hand lettering isn't all that unusual, but the blurred effect of the type on this poster does make it stand out.

Add to that the faded, water-blur effect of the type at the bottom of the poster, and it becomes a visual magnet.

The red gator at the bottom adds contrast that makes this a very powerful piece.

creative firm
DJG Design
designer, copywriter
Danny J. Gibson
client
Jason Lewis

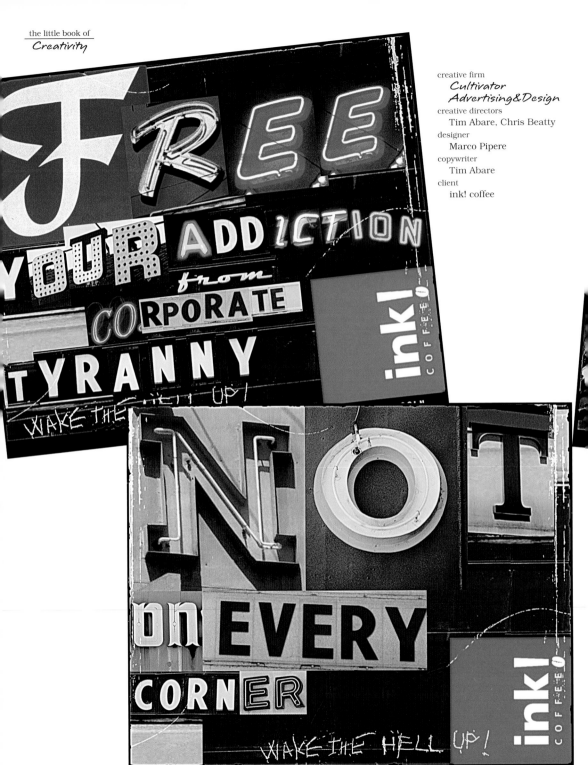

creative firm
**Cultivator
Advertising&Design**
creative directors
Tim Abare, Chris Beatty
designer
Marco Pipere
copywriter
Tim Abare
client
ink! coffee

Creative assignment: do ads so that a local coffee shop can compete with the BIG guys, the ubiquitous coffee giant. Tough assignment, but great creative people rise to the occasion.

The clever use of type and the sharp copy make this campaign a creative winner. And very memorable.

Japanese type reads from top to bottom.

So, this poster featuring a Japanese Elephant uses the top-to-bottom flow of the letters.

By extending the trunk downward into the type, the reader's eye is led even farther down the page to the copy details.

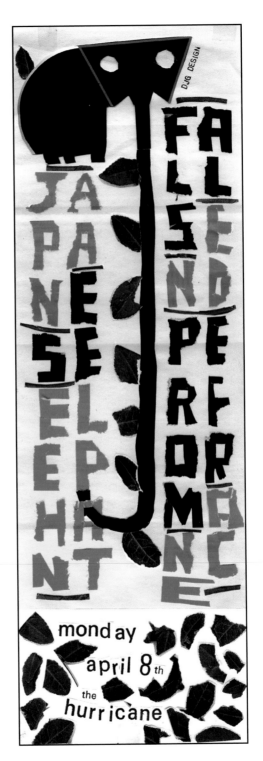

creative firm
DJG Design
designer, copywriter
Danny J. Gibson
client
Chris Stewart

This illustration is type. Type and then more type. The multiple layers of type simply and creatively emphasize the topic: Cyberspace and a Civil Society.

creative firm
Henderson Bromstead
designer, illustrator
Hayes Henderson

Winter can be a
time to bundle
up and stay
inside, but this
poster suggests
that the scarf of
quality enter-
tainment can
be a good
reason to
venture out into
the cold and
snow. Compel-
ling design and
highly creative
use of type.

creative firm
 Henderson Bromstead
art director, designer, illustrator
 Hayes Henderson
designer, illustrator
 Billy Hackley

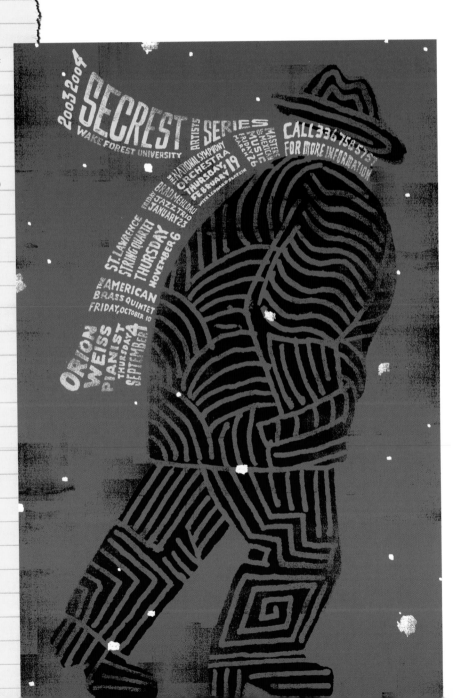

The cut-and-paste type here draws the eyes into the illustration.

In fact, the type becomes the illustration.

Look at it closely and you'll see that the drawing is actually just an outline, and the type makes it come alive. Powerful communication comes in many forms. This is one of them.

creative firm
Modern Dog Design
art director, designer, illustrator
Robynne Raye
client
House of Blues

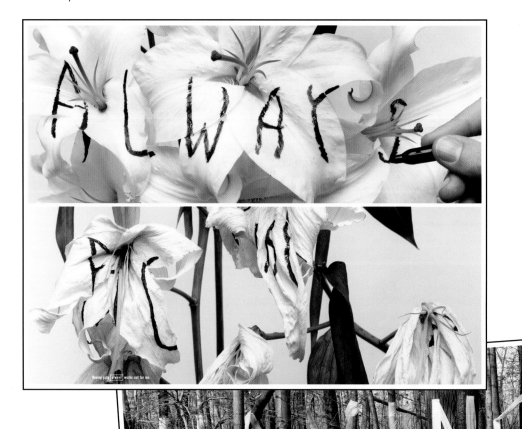

creative firm
Sagmeister Inc.

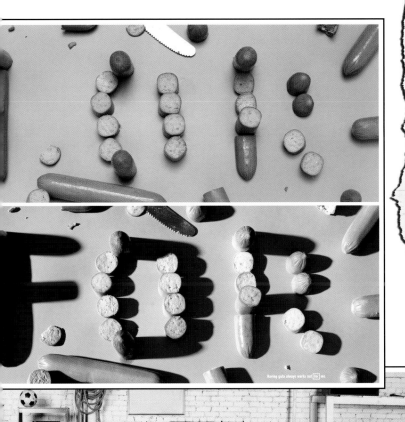

Creativity is seeing things in very different ways from the ordinary. The "always" flowers piece shows just how long "always" can be. The others are typographic images created in most unusual ways. The top photo shows one view while the bottom shows a completely different look. There are few better examples than these to show how very creative minds can expand boundaries.

Multiple colors,
multiple concerts.

The many images
of this illustration
come through
when all the colors
are viewed
separately. But it
is the clever use of
type that make
this a really power-
ful poster.

creative firm
Henderson Bromstead
art director, designer, illustrator
Hayes Henderson
designer, illustrator
Billy Hackley

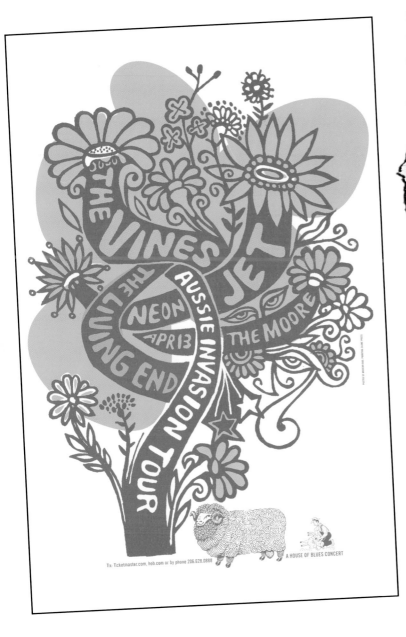

In this flashback to the 1970s, this poster has a pop art look that uses typography as an illustration tool.

Note that this is a two-color poster, yet it has all the appeal of a process color job.

creative firm
Modern Dog Design
art director, designer , illustrator
Vittorio Costarella
client
House of Blues

The cut-and-paste type here draws the eyes into the illustration.

In fact, the type becomes the illustration.

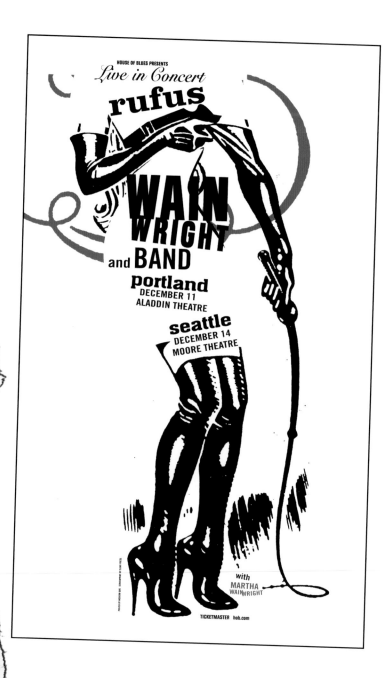

creative firm
Modern Dog Design
art director, designer, illustrator
Vittorio Costarella
client
House of Blues

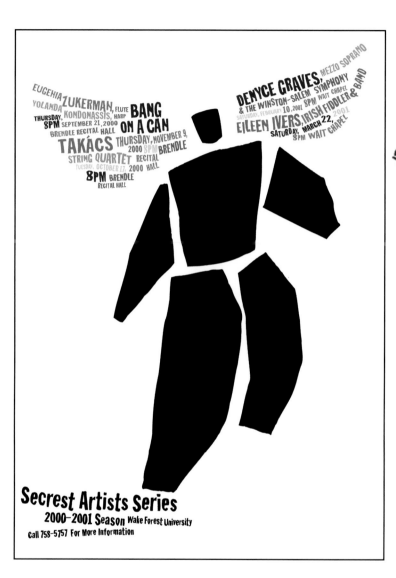

The use of type to make wings on the human figure is a visually powerful way to make a statement. Add to that the multiple colors to promote the different events, and you have a poster with a long life and lots of appeal.

creative firm
Henderson Bromstead
designer, illustrator
Hayes Henderson

creative firm
Sagmeister

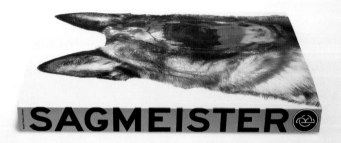

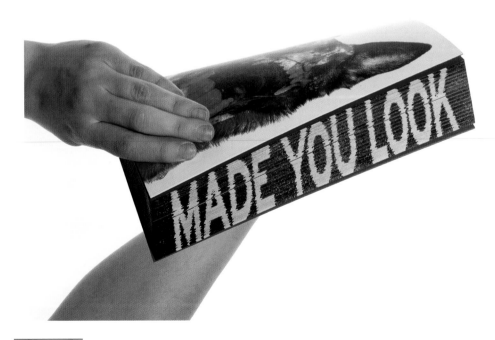

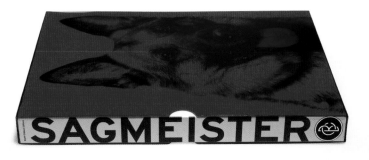

Creative solutions to normal problems are what this book is about. Book design projects are commonly seen in terms of a jacket, or perhaps a grid system. The cover for this book has two views, depending upon the angle which is viewed. And the page edges...one view shows bones (there *is* a dog on the cover), while seen from a different angle, "Made You Look" appears. Great work, by thinking beyond normal boundaries.

The typography here is the dominant element, although the eye first goes to the red clothing on the man sitting (is he in the audience at one of the concerts?). The multiple events in the series are promoted in this poster and the type spacing and weight make a difficult assignment come off with a high level of creativity.

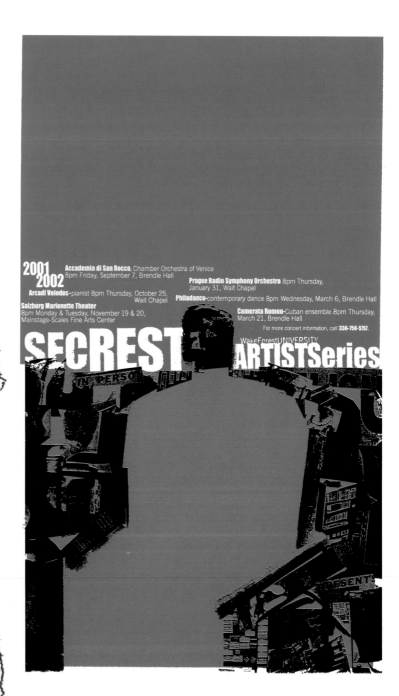

2001
2002

Accademia di San Rocco, Chamber Orchestra of Venice
8pm Friday, September 7, Brendle Hall

Prague Radio Symphony Orchestra 8pm Thursday,
January 31, Wait Chapel

Arcadi Volodos-pianist 8pm Thursday, October 25,
Wait Chapel

Philadanco-contemporary dance 8pm Wednesday, March 6, Brendle Hall

Salzburg Marionette Theater
8pm Monday & Tuesday, November 19 & 20,
Mainstage-Scales Fine Arts Center

Camerata Romeu-Cuban ensemble 8pm Thursday,
March 21, Brendle Hall

For more concert information, call **336-758-5757.**

SECREST ARTISTSeries

WakeForestUNIVERSITY

creative firm
Henderson Bromstead
designer, illustrator
Hayes Henderson

The red ribbon is there, but so are intertwined arms, and then type. Clever use of type in an invitation to a fund raiser. Note that this is a one-color piece; yes, highly creative and low printing costs are compatible. *If* the idea is great.

creative firm
Henderson Bromstead
art director, illustrator
Hayes Henderson
art director, designer
Brent Piper

The copy for this ad is simple. "My mom's going to kill me."

But then you see the copy again, not at the girl's head, but next to her stomach.

Simple, yet powerful ad shows just how the right words can communicate.

creative firm
BBDO
creative directors
Bill Pauls, Rich Wakefield
art directors
Jessica Foster, Rich Wakefield
copywriter
Jean Weisman
photographer
Jim Fiscus

My mom's going to kill me.

My mom's going to kill me.

One condom saves both lives.
Save the Children.

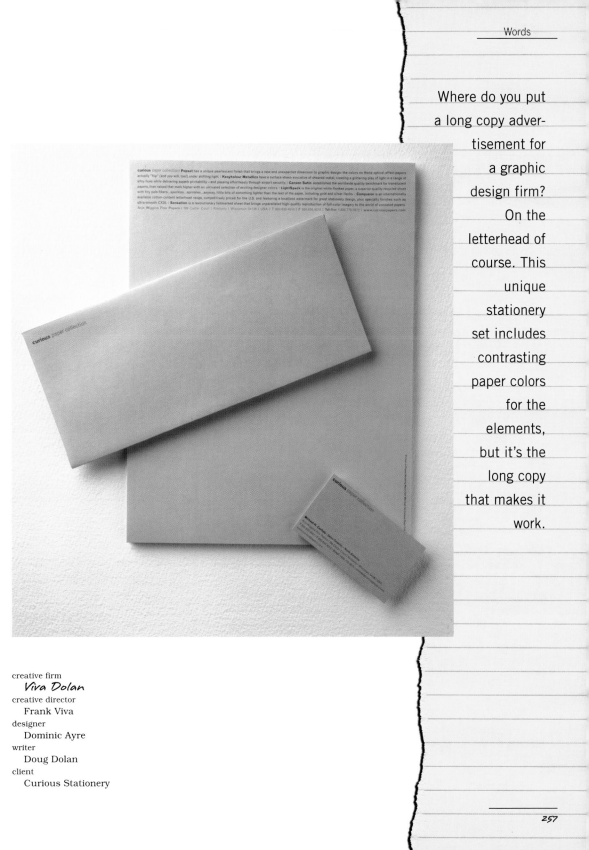

Where do you put a long copy advertisement for a graphic design firm? On the letterhead of course. This unique stationery set includes contrasting paper colors for the elements, but it's the long copy that makes it work.

creative firm
Viva Dolan
creative director
Frank Viva
designer
Dominic Ayre
writer
Doug Dolan
client
Curious Stationery

I'm not sure which category should include this project, but it does belong in the book. This is a corporate identity system for the town of Murray, Utah. The basic symbol is shown at the top, and the many departments have a minimal variation, while remaining consistent with the primary mark.

OK, this doesn't belong in the "words" section of this book, but it is a good example of creativity within a rigid structure. Nice job.

MURRAY

MURRAY
CENTENNIAL

MURRAY
FIRE
DEPARTMENT

MURRAY
POLICE
DEPARTMENT

MURRAY
CITY
POWER

MURRAY
OFFICE OF
THE MAYOR

MURRAY
CITY
COUNCIL

MURRAY
CITY
ATTORNEYS

MURRAY
MUNICIPAL
JUSTICE COURT

MURRAY
PARKS &
RECREATION

MURRAY
PUBLIC
SERVICES

MURRAY
INFORMATION
SYSTEMS

MURRAY
CITY
RECORDER

MURRAY
FINANCE &
ADMINISTRATION

MURRAY
ECONOMIC
DEVELOPMENT

MURRAY
CITY
TREASURER

MURRAY
HUMAN
RESOURCES

creative firm
A N D
art directors
Scott Arrowood,
Douglas Dearden
designer
Brian McDonough
client
City of Murray, Utah

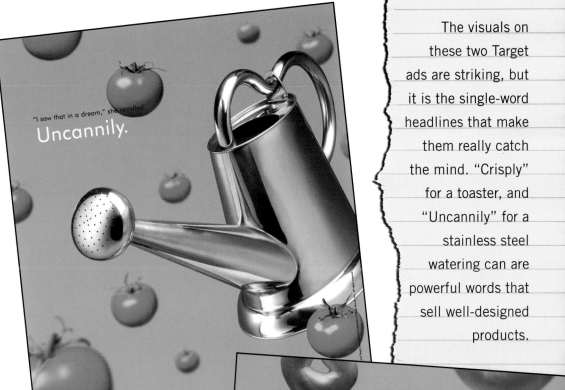

"I saw that in a dream," she recalled

Uncannily.

Michael Graves Design™
Stainless Steel Watering Can $29.99

The visuals on these two Target ads are striking, but it is the single-word headlines that make them really catch the mind. "Crisply" for a toaster, and "Uncannily" for a stainless steel watering can are powerful words that sell well-designed products.

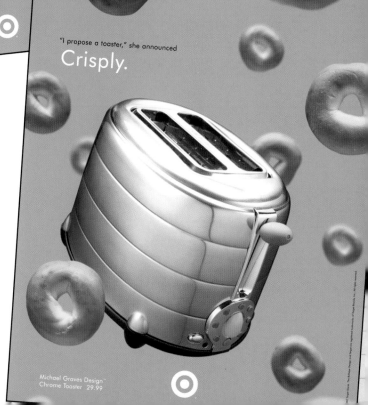

"I propose a toaster," she announced

Crisply.

Michael Graves Design™
Chrome Toaster 29.99

creative firm
 Templin Brink Design
creative directors, designers
 Joel Templin, Gaby Brink
copywriter
 Jeff Iorillo
photographer
 David Campbell
client
 Target/Michael Graves Collection

Song Airlines is a Delta creation, but with a peppy attitude. These employee recruitment posters reflect the "I'd like to work there" spirit that pervades at Song. One "passenger conversation starter," for example, is "Do you fly anywhere you want for free? I do."

Once you have read just one of the clever lines, you have to read them all. And that's where the "Wanna work with us" message comes in.

creative firm
Templin Brink Design
creative directors
Joel Templin, Gaby Brink
designer
Brian Gunderson
illustrators
Brian Gunderson,
Marius Gedgaudas
client
Song Airlines

Even if you aren't into blues music, you'll enjoy reading the copy and then making up your own blues song.

While you're at it, you just might decide that it would be fun to attend a blues concert.

★ CREATE YOUR OWN BLUES SONG

Just fill in the words. Play by yourself or with friends!

Woke up this _____ , had to find my _____ .
(time of day) *(article of clothing)*
Woke up this _____ , had to find my _____ .
(time of day) *(article of clothing)*
My baby's gone and left me, skipped town with _____ .
(name of best friend)

I'm going to _____ them, bring her back home
(verb)
I'm going to _____ them, bring her back home
(verb)
Tell everyone in _____ , to feed _____ while I'm gone.
(name of town) *(name of pet)*

Now 1 and 1 is _____
(number between 1 and 10)
2 and 2 is _____
(number between 1 and 10)
She's done it _____ times, should've known she'd do it some more.
(number between 1 and 10)

Now I feel so _____ , you hear me when I _____
(emotion) *(bodily sound)*
Now I feel so _____ , you hear me when I _____
(emotion) *(bodily sound)*
I've been so lonely for _____ , ever since you've been gone.
(noun)

Oh _____ , don't you want to go.
(term of endearment)
Oh _____ , don't you want to go.
(term of endearment)
Come back home, home to sweet _____ .
(name of Northern U.S. city)

Now all you need is the music. Find it Saturday, September 22nd at Uptown at Central Park, Fredericksburg, Virginia. Come see Roomful of Blues, Cephas & Wiggins, Big Jesse Yawn, Jailtones, Linwood Taylor, Archie Edwards, and Sheryl Warner and the Southside Homewreckers. It'll be much, much better.

BLUES IN THE 'BURG

"Where the blues never get old"

www.bgcfxbg.org • For more info call 540-785-6472 • Tickets available through www.TicketWeb.com • Benefits the Boys and Girls Club of Greater Washington, Fredericksburg Regional Branch.

creative firm
Arnika
art director
Michael Ashley
copywriters
Michael Ashley, Dinesh Kapoor
client
Boys and Girls Club of America

BLUES NAME STARTER KIT ★

Take one name from each column and voilá! Your very own blues name!

PHYSICAL INFIRMITY	FIRST NAME (OR FRUIT)	LAST NAME OF A PRESIDENT
		Jefferson
Blind	Lemon	Washington
Little	Willie	Fillmore
Crippled	Banana	Johnson
Bucktooth	Kiwi	Clinton
Short	Virgil	Bush
Asthmatic	Peach	Carter
Skinny	Joe	Coolidge
Wet	Mango	Ford
Fat	Billy	Hoover
Varicose	Strawberry	Polk
Corn-toed	Enis	Tyler
Arthritic	Jethro	Pierce
Sweaty	Tomato	Jackson
Peg-legged	Melon	Lincoln
Stinky	Papa	Hayes
Mangy	Pear	Cleveland
Rickety	Sherman	Taft
Dehydrated	Johnny	Taylor
Scabby	Lychee	Wilson
Bald	Cherry	Nixon
Deaf	Eustis	

Now all you need is the music. Find it Saturday, September 22nd at Uptown at Central Park, Fredericksburg, Virginia. Scabby Joe Coolidge won't be there, but Roomful of Blues, Cephas & Wiggins, Big Jesse Yawn, Jailtones, Linwood Taylor, Archie Edwards, and Sheryl Warner and the Southside Homewreckers will be.

BLUES IN THE 'BURG

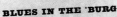

"Where the blues never get old"

www.bgcfxbg.org • For more info call 540-785-6472 • Tickets available through www.TicketWeb.com • Benefits the Boys and Girls Club of Greater Washington, Fredericksburg Regional Branch.

You get hooked on this copy in about 3 seconds.

You find yourself making up names for Blues singers.

Then you substitute your own name in there, and before long, you're thinking that it just might be fun to attend the concert.

The little blue-haired lady laughed and cried so much that she actually...peed.

Very funny line (and an opening for a possible product placement for Depends).

The comic book style of the piece simply enhances the copy and the overall impact of the poster.

creative firm
Lure Design
designer
Jeff Matz
illustrator
Greg Rebus
copywriter
Jane Harrison
client
Florida Film Festival

TRADE SECRETS

FROM RICHARD BOYNTON ('93)

② 99°

Wink

0.5 FL OF IT ®

Each

*FOR A LIMITED TIME ONLY, WHILE SUPPLIES LAST. OFFER GOOD 12/13/01 AT THE FLAGLER COLLEGE AUDITORIUM (7PM)

Paper: Potlatch McCoy Uncoated 100#C / Printing: C&H Printing, Incorporated (Jacksonville, Fla)

OK, let's do an ad for a creative guy who will be speaking to people and telling just how good he is and how they can maybe be just as good…someday. Lots of creative people talk to lots of groups, so this is a common assignment. Here's an un-common solu-tion. The headline' "Trade Secrets 99 cents" grabs you immediately. Not much copy because not much is needed.

creative firm
 Wink Inc.

scott mires
principal/creative director

mires › design for brands™

2345 kettner blvd
san diego, ca 92101

p. 619 234 6631
f. 619 234 1807

scott@miresbrands.com
www.miresbrands.com

www.miresbrands.com
san diego, ca 92101
2345 kettner blvd

mires › design for brands™

The stationery
system for Mires
uses the phrase
"design for brands"
to position them-
selves as much more
than the usual
graphic design firm.
And when you see
their work, you
realize that's what
they are.

mires › design for brands™

creative firm
Mires
creative director
John Ball
designer
Miguel Perez
copywriter
Eric LaBrecque
client
Mires

By using phrases like "asking directions" and "rush hour," the Lewis & Clark ads show just how difficult the expedition really was.

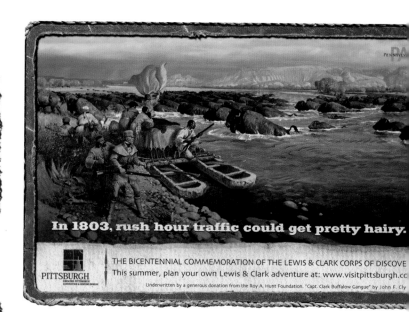

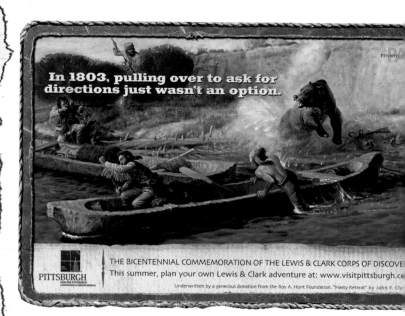

creative firm
Blattner Brunner
chief executive director
Bill Drake
creative director
Dave Vissat

copywriter
Ray Pekich
illustrator
John F. Clymer
client
Greater Pittsburgh
Convention & Visitors Bureau

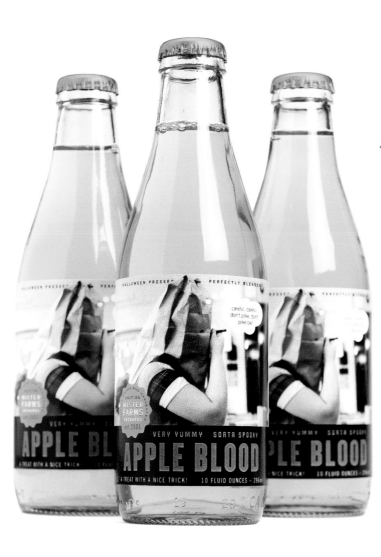

Right away you get the idea that this isn't your average package. The label features a girl with a sack over her head, drawing a face, being careful not to poke her eye out...And then...then you see the name of the product: Apple Blood. A great item to give to Halloween trick-or-treaters.

creative firm
 AND
art directors
 Douglas Dearden, Scott Arrowood
designer
 Douglas Dearden
client
 Appleblood Cider and Bottling

Bold graphics are used in this series, but it's the words that grab you. "At our school, all the teachers are half-naked."

Brilliant words.

WE ENCOURAGE OUR STUDENTS TO FLOAT THROUGH LIFE.

AMERICAN RED CROSS
AQUATIC SCHOOL

TO LEARN ABOUT OUR LIFEGUARD TRAINING CLASSES, MAY 9-12 AND MAY 16-19, CALL 412-263-3106.

OUR STUDENTS EITHER PASS OR FLAIL.

AMERICAN RED CROSS
AQUATIC SCHOOL

TO LEARN ABOUT OUR LIFEGUARD TRAINING CLASSES, MAY 9-12 AND MAY 16-19, CALL 412-263-3106.

AT OUR SCHOOL, ALL THE TEACHERS ARE HALF-NAKED.

AMERICAN RED CROSS
AQUATIC SCHOOL

TO LEARN ABOUT OUR LIFEGUARD TRAINING CLASSES, MAY 9-12 AND MAY 16-19, CALL 412-263-3106.

creative firm
Blattner Brunner
group creative director
Bill Garrison
creative director
David Hughes
designer
Dave Vissat
client
American Red Cross

creative firm
Blattner Brunner
chief executive director
Bill Drake
creative director
Jay Giesen
associate creative director
Andy McKenna
photographer
Duane Rieder
client
Zippo

Just how strong and long-lasting is a Zippo? By comparing it with a tailpipe, this ad gives us an idea. And by having the father as "unknown" just adds to the Zippo mystique.

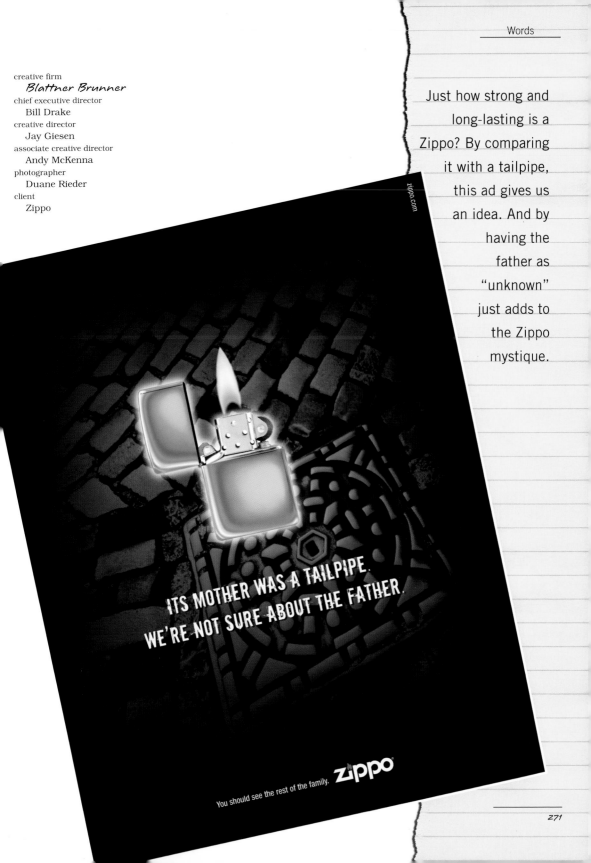

ITS MOTHER WAS A TAILPIPE.
WE'RE NOT SURE ABOUT THE FATHER.

You should see the rest of the family. **zippo**

Index